Digital SLR

From **Click** to **Print**

Digital SLR

From **Click** to **Print**

The go-to guide for tips, techniques,
and photographers' tricks

Will Cheung

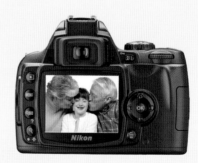

Reader's Digest

The Reader's Digest Association, Inc.
Pleasantville, New York/Montreal/Sydney/Singapore

A READER'S DIGEST BOOK

This edition published by The Reader's Digest Association, Inc.,
by arrangement with Ilex Press Limited

FOR ILEX PRESS
Publisher: Alastair Campbell
Creative Director: Peter Bridgewater
Managing Editor: Chris Gatcum
Senior Editor: Adam Juniper
Art Director: Julie Weir
Designer: Ginny Zeal
Design Assistant: Emily Harbison

FOR READER'S DIGEST
U.S. Project Editor: Kim Casey
Copy Editor: Barbara Booth
Canadian Project Editor: Pamela Johnson
Australian Project Editor: Annette Carter
Senior Art Director: George McKeon
Executive Editor, Trade Publishing: Dolores York
Associate Publisher: Rosanne McManus
President and Publisher, Trade Publishing: Harold Clarke

Library of Congress Cataloging-in-Publication Data:

Cheung, William.
 Digital SLR from click to print : the go-to guide for tips, techniques,
and photographer's tricks / William Cheung.
 p. cm.
 Includes index.
 ISBN 13: 978-0-7621-0928-9
 1. Photography--Digital techniques--Amateurs' manuals. 2.
Digital cameras--Amateurs' manuals. 3. Single-lens reflex cameras--
Amateurs' manuals. I. Title.
 TR267.C44 2008
 771.3'3--dc22
 2008018652

We are committed to both the quality of our products and the service
we provide to our customers. We value your comments, so please feel
free to contact us.

 The Reader's Digest Association, Inc.
 Adult Trade Publishing
 Reader's Digest Road
 Pleasantville, NY 10570-7000

For more Reader's Digest products and information, visit our website:
 www.rd.com (in the United States)
 www.readersdigest.ca (in Canada)
 www.readersdigest.co.uk (in the UK)
 www.readersdigest.com.au (in Australia)
 www.readersdigest.com.nz (in New Zealand)
 www.rdasia.com (in Singapore)

Printed in China

1 3 5 7 9 10 8 6 4 2

Contents

Foreword

The digital SLR in your hands, which I imagine is probably new and the reason you are reading this book, looks and feels almost identical to any film single-lens reflex. Apart, that is, from the screen on the back, which promises a view of something. This view, which is an instant replay of any picture taken and, in the case of some models, a live preview of what you are about to take, is also a window into a new and intensely rewarding process of creating images.

Digital photography has nearly all but phased out film, and most people are familiar with it. But the single-lens reflex offers a different experience. This is a camera that transformed the art of photography when it became the standard for 35 mm shooting, a design so close to mechanical perfection that it has been re-adopted for the digital age.

But what makes a digital SLR different from ordinary point-and-shoot digital cameras is choice. Most obviously, there is the choice of lenses, which you can add to as your photography expands, along with a potpourri of other accessories that can offer you all kinds of fun, interesting results. More than this, however, is the ability to move away from automated photography. But why would you want to do this, when the camera manufacturer has gone to so much effort to make the entire operation trouble-free? Simply because photography at any level above the don't-care snapshot is about self-expression. The images you make are seen only by you, and with the best intentions in the world, the manufacturer's auto settings can produce only what most people would choose. And there is so much choice: focus, depth of field, fast-action effects, brightness, contrast, color balance—the list goes on and on.

You have in your hands a highly sophisticated image-making engine that will do almost anything you demand of it, and this book, produced by some of the most experienced editors in photographic publishing, will show you how to exploit this to the fullest.

Michael Freeman

Michael Freeman is a world-renown travel photographer who has totaled more than thirty years experience shooting for famous names like *Time-Life*, *Condé Nast Traveller*, and *Smithsonian* magazine since he graduated from Oxford University, England. His works have sold over 1 million copies and received international acclaim, including the Prix Louis Philippe Clerc.

Introduction

If you want to take your photography to the next level, the digital SLR offers something the compact camera cannot: the chance to explore your creative depths, and take advantage of manual and automatic functions. In other words, it offers the chance to continually revolutionize your work.

It does this not through increased resolution—though you won't find any SLR models lacking—but through quality and flexibility. Digital SLRs, like their film-based predecessors, pack two huge advantages over their compact brethren; interchangeable lenses, which make it possible to adapt your camera to any situation, and a real viewfinder that works directly through whichever lens you've chosen.

Digital SLRs are also equipped with a potentially bewildering array of options and features that can all be used to improve your photography, including complicated autofocus systems, light-measuring systems, adjustable flashes, and so on. This book will help you understand all of these and show you how to use them, together with time-honored photographers' techniques, to provide wonderful and unique digital photos.

Introducing Digital Photography

1

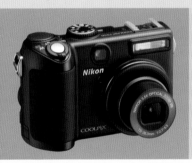

Welcome to digital photography

Digital imaging has taken the world of photography by storm, and it has forever changed the way we take pictures. It is immediate, convenient, incredibly versatile, and there are no film purchase and processing fees involved.

Digital compact cameras have all but taken over from film models, and the growth in the digital single-lens reflex (DSLR) camera market is continuing at a steady pace, attracting countless photographers of all experience levels.

So whatever your background, welcome to the world of digital SLR photography.

The latest digital sensors provide high picture quality, lifelike color reproduction, and low noise, and they can record a wide dynamic range.

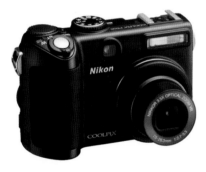

This Nikon digital compact camera is very capable as well as portable, but changing the lens is impossible.

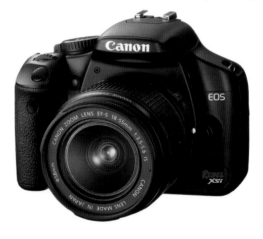

The Canon Rebel XSi is a good example of a mainstream digital SLR, in terms of both price and features.

A SHORT HISTORY LESSON

Film is still used by many people, but digital technology offers another way of enjoying photography. The increasing resolution and affordability of DSLR cameras give them a broad appeal that has mostly ended the film-versus-digital debate.

During the infancy of digital cameras, most concerns were about image quality. The Canon EOS D30, which was considered state of the art in 2000, had a resolution of three megapixels. It could not compare with 35-mm format film, which had an equivalent resolution of at least 16 megapixels.

Over the past few years, however, technology has moved rapidly forward, and there is no doubt now that digital is an imaging medium comparable to film in almost every way. Its color reproduction is lifelike, digital noise is much less of an issue—even at high ISO settings—and the latest DSLRs are easy to handle.

COMPACT VERSUS DSLR

Many more compact cameras than DSLR cameras are sold each year. Compacts, by their nature, are very convenient and simple to use, and most have a built-in zoom lens that allows the photographer to tackle a wide range of subjects. Some models

have a zoom range of 10x or even 12x, so very distant subjects appear to be a good size in the viewfinder rather than as specks in the distance.

There are many people who are perfectly happy with their feature-rich compact cameras, and they see no justifiable reason to move up to a DSLR. However, one feature the DSLR offers over the compact is the option of interchangeable lenses.

The ability to change lenses also gives you the flexibility to use a lens that suits the subject as well as your budget. So whether you prefer photographing scenes, wildlife, or your family, the DSLR provides the the option of fitting a lens that suits your vision of that subject.

DSLR cameras have several other advantages over compacts. For example, DSLRs handle better, and being able to view the image through the lens—often referred to as TTL—allows for precise compositions.

Picture quality from a DSLR is also superior, even when compared with a compact camera that has the same resolution. Compact cameras use smaller sensors, so the pixels—individual light-sensitive elements—are very tightly packed together, which makes them more prone to the impact of digital noise.

The DSLR does not suit every photographer, but if you want to take your photography to a higher level, in which you are the one in control, then this camera is ideal.

MEMORY CARD FORMATS

When you take a picture on a digital camera, it is recorded onto a solid-state flash memory storage card. Flash memory offers fast read/write times, and no power is needed to maintain the data written to the card. Flash memory cards are also very reliable, and they can withstand extreme conditions.

There are several storage formats; however, CompactFlash and Secure Digital are the most popular.

CompactFlash

There are two CompactFlash (CF) formats: Type I and Type II. Most DSLRs use Type I cards—reliable flash memory devices. Currently 16 GB is the largest size.

The Type II card is a miniature hard drive. But because it is a mechanical device, it is less reliable and slow, so they are rarely used in DSLRs.

xD Picture Card

xD is the smallest format used in digital cameras. They are flash memory cards, although this format is used only in compact cameras.

Secure Digital

Secure Digital (SD) cards are very common. They are used in digital cameras, PDAs, mobile phones, and some laptop computers.

To satisfy the demand for higher capacities, the SD card was internally redesigned to the 2.0 specification, or Secure Digital High Capacity (SDHC), to allow for cards of 4 GB and more. The newer SDHC cards are not backward-compatible and cannot be used in some older cameras.

Memory Stick

Introduced by Sony, this flash memory family is used in digital cameras as well as Sony-branded laptop computers and Sony's range of electronic games. Sony DSLRs offer Memory Stick and CompactFlash compatibility.

The anatomy of a DSLR

Knowing your way around your DSLR camera will increase your enjoyment of photography. Knowledge and familiarity will also give you more control and help build confidence as you start to explore the world with your camera lens.

Every camera is different, and your model might not be the one explained on these pages. However, the design layout of DSLR controls is primarily the same across the main brands.

Direct print
Starts printing when the camera is connected to a PictBridge printer or PTP transfer when connected to a computer.

Sensors
Detect when your eye is at the viewfinder, then switch off the monitor with its camera-settings menu.

Exposure compensation
Adjusts the input dial to give more or less exposure. Needs to be reset to zero after use.

Dual function buttons
Zooms in or out of review images to check sharpness while in image playback mode. In normal use they are the automatic exposure lock (AEL) and autofocus zone selection buttons.

Display button
Shows or hides the camera-settings screen.

Menu button
Calls up the camera's menu on the monitor.

Jump button
Allows you to move back and forth in 10 or 100 picture steps during image playback.

Drive
Sets single-frame or continuous shooting. Self-timer operation is usually set from here, too.

Mode controls
Deal with key camera functions: ISO sensitivity, AF (autofocus), WB (white-balance), and exposure metering pattern. The central SET button confirms your choice. The SET button doubles as a picture-style selection control.

Playback button
Reviews your pictures on the rear monitor.

Wastebasket
Deletes unwanted images. Deletion can be made immediately after a shot has been taken, or later as you browse through all the photos on your memory card.

The LCD monitor
Enables you to preview your pictures, check camera settings, change menu items, and—on DSLRs with live view—compose pictures.

Self-timer LED
Blinks to indicate the countdown in the self-timer operation. Speeds up just prior to the shutter firing.

Integral flash
Can be set to fire automatically or manually. It will have red-eye reduction, off, and fill-in modes, too.

Take lots of pictures
Since there is no extra cost and the feedback is instant, take many pictures to get a feel for the camera. You do not have to download them. It can be an exercise in getting to know your camera and its controls.

Shutter release
When pressed halfway, this button activates the focusing and metering systems. When pressed all the way down, it takes the photograph. In continuous shooting mode, the camera will continue taking pictures until your finger is taken off the shutter release.

Lens release button
While twisting, this releases the lens.

Handgrip
Provides a secure hold and contains the battery and memory card.

Filter thread
Accepts filters. The size is usually denoted on the front of the lens. On this lens, the filter thread is 58 mm.

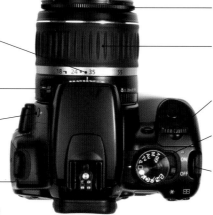

Focal lengths
Refer to the focal length of the lens.

AF/Manual
Enables you to alternate between automatic and manual focusing.

Flash up
Press this and the flash pops up.

Accessory shoe
Accommodates separate flashguns, and the contacts allow communication between the two units. Often called the hotshoe. Also holds camera accessories such as a spirit level.

Manual focus ring
Manually adjusts the focus.

Zoom barrel
Changes the lens's focal length and the view in the viewfinder when twisted.

Input dial
Allows speedy adjustment of camera settings.

Exposure mode dial
Chooses the exposure mode.

On/off switch
The camera's master switch. Most DSLR cameras have an auto power off to conserve the battery.

Viewfinder eyepiece
May have a diopter adjustment control, which can be adjusted to suit different eyes.

DSLR lenses

Zoom lenses cover a range of focal lengths, which means you can shoot a variety of photographs without moving from your spot.

Most DSLR cameras are sold with a standard zoom lens. This lens covers a range from wide-angle to short telephoto, which is something that is approximately 18–55 mm or 18–70 mm. This range is suitable for a wide range of general subjects, and many camera users are happy to stick with a standard lens. However, the ability to change lenses on a DSLR camera gives you a major advantage over a compact camera. It also means you can buy extra lenses to suit the types of photography you enjoy most.

LENS OPTIONS

There is a wide range of lenses to suit all budgets and all kinds of photographic situations.

The lenses are available from the camera manufacturers themselves or from third-party companies (known as independent brands). Independent brands can offer a cost saving compared with name brands.

A huge majority of lenses sold and used today are zooms, but not all lenses have this adjustable focal length. These non-zooms are also known as prime lenses. They are used mostly by experienced photographers, who tend to value the subtle quality improvements gained because there are fewer glass elements needed in the construction of a prime lens.

Every zoom lens encompasses a focal-length range, and you can use any setting within that range by turning the zoom ring on the lens. For example, a 28–135-mm zoom means that it has a focal length of 28 mm at the short end and 135 mm at the long one. Every zoom is marked with its range.

THE CROP FACTOR

The pictorial effect of a specific lens needs explanation because sensor sizes vary from camera to camera.

It was easier when the 35-mm full-frame film format dominated photography. In that format, which measures 24 × 36 mm, a lens with a focal length of 43 mm is the theoretical standard. It provides a perspective and angle of view that approximate that of the human eye. A focal length shorter than 43 mm gives a broader viewing angle; therefore, these lenses are called wide-angles. Conversely, a focal

length that is longer than 43 mm has a narrower angle of view and is called a telephoto.

There are 35-mm full-frame format DSLRs available, but most DSLRs use imaging sensors that are smaller than the 24 × 36-mm size of the 35-mm format. For example, the Canon EOS 400D sensor measures 14.8 × 22 mm, and the Nikon D40x's is

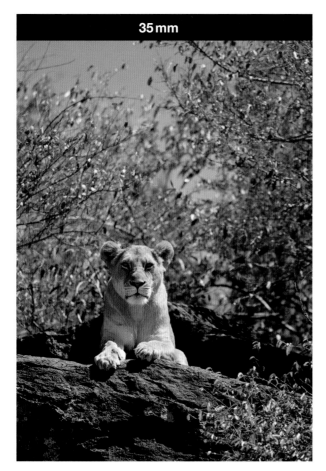

35 mm

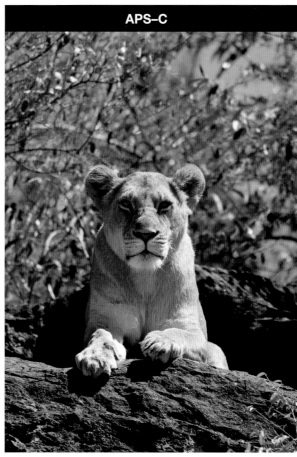

APS-C

15.6 × 23.7 mm. This smaller format is generically known as APS-C.

A lens's focal length remains constant, but a smaller sensor means there is a magnifying effect and an increase in a lens's effective focal length. This is often called the field-of-view crop factor, because the effect is similar to cropping an image.

The crop factor depends on the sensor size. On the Canon EOS 400D, the crop factor is 1.6×, and on the Nikon D40x it is 1.5×. Therefore, a 100-mm lens has an effective focal length (EFL) of 160 mm on the Canon and 150 mm on the Nikon.

This was an issue at the wide-angle end of the focal-length range, but manufacturers have addressed this, and now there are lenses such as 10–20 mm that genuinely provide wide focal lengths.

This effective focal-length magnification is a major benefit for wildlife photographers because a 300-mm telephoto used with a 1.5× crop factor becomes an effective 450-mm telephoto.

With the same focal-length lens, DSLRs with APS-C size-imaging sensors give an effective focal-length increase compared with the 35-mm format. This pair of images shows the effective increase in a camera with a 1.6× crop factor compared with a 35-mm full-frame image.

Lens types

When purchasing a lens, keep in mind your budget as well as your photographic interests. Many avid photographers have outfits based on two zoom lenses—a wide-angle and a telephoto—to cover all of their needs.

Zoom lenses can be broken down into five broad categories, although some wide-ranging zooms will cut across categories.

WIDE-ANGLE ZOOM

Examples: 10–22 mm, 16–35 mm, 17–40 mm
A wide-angle zoom produces a wider angle of view than a standard zoom, so it is usually used for interiors, landscapes, and photography in confined areas. Wide-angle lenses also allow you to use foreground detail more effectively and offers good depth of field—sharpness of objects near and far from the lens.

STANDARD ZOOM

Examples: 17–55 mm, 18–70 mm, 24–70 mm, 28–75 mm
A typical standard zoom covers a range from moderate wide-angle to short telephoto. If you want to carry only one lens, the standard zoom is the one to use.

SUPERZOOM

Examples: 18–200 mm, 28–200 mm, 28–300 mm
A superzoom's wide focal-length range makes it the perfect all-around lens. However, this type of zoom is relatively bulky compared with a standard zoom, and its image quality can be less impressive than lenses that cover a smaller range.

How to avoid flare

Stray light striking the front of the lens can create a flare that will reduce your image contrast. In the worst cases, you may get flare spots, but the risk of flare can be minimized by using a lens hood or shade. A lens hood also offers a degree of physical protection. Some lenses have an integral lens hood that slides out, but many more have hoods that screw or bayonet onto the front of the lens. Many lenses come supplied with a dedicated hood.

Caring for your lenses

Lens surfaces are very sensitive and can be easily scratched, so always exercise caution when handling them. Back and front caps always need to be in place when the lens is not in use. As an extra precaution, a skylight or ultraviolet filter should be left on the front of the lens permanently. This will keep dust and stray fingers off the front surface of the lens. And if the filter is damaged, it can easily be replaced, and at minimal cost.

TELEPHOTO ZOOM

Examples: 50–200 mm, 70–200 mm, 70–300 mm

Telephoto lenses make distant subjects appear larger in the viewfinder. A focal length of 85–100 mm is known as a short telephoto, while a length of 300 mm or 400 mm is a long telephoto. The longer the lens, the greater the magnification. However, this also causes the risk of camera shake to be greater. Telephoto lenses are used for many subjects; a focal-length range of 50–200 mm is ideal for all-purpose photography.

LONG TELEPHOTO ZOOM

Examples: 200–400 mm, 170–500 mm

Long telephoto zooms are specialized optics often used by action and wildlife photographers. They are bulky, heavy, and generally tend to be very expensive.

MACRO LENSES

Examples: 60 mm, 100 mm, 150 mm

Macro lenses are designed to focus more closely than conventional lenses to make small subjects appear larger in the viewfinder. Typically, a macro lens provides lifesize magnification, which is denoted as 1:1. This means that a subject will appear as actual size on the sensor. In fact, a 1:1 image is the original technical meaning of the term macro, but now it has a broader meaning of any close-focusing lens.

While macro lenses are designed to work at close focusing distances, they are just as proficient at longer distances, and they can be used for general photography.

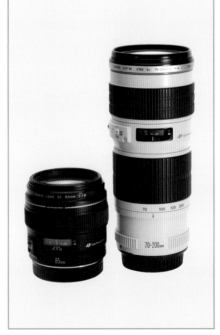

📷 WHAT IS A PRIME LENS?

A prime lens has a single fixed focal length. With a prime lens, you have to change your position to take pictures with different viewpoints.

Although the effect is less pronounced today than in the past, photographers have often favored prime lenses because their optics are less complicated than zoom lenses, which require more glass components.

Therefore, a prime lens can be smaller and lighter than a zoom lens. And it often features a wider maximum aperture, which is important in creative photography (see page 32).

Essential camera accessories

The digital SLR camera is the centerpiece of your system. However, there are many accessories to choose from. With so many options, you will have to decide which items are essential and will enhance your enjoyment of photography, and which would be nice to have but can wait until your budget permits it.

CAMERA SUPPORTS

The most useful camera support is the tripod. It provides excellent camera stability and allows for complete freedom with your camera settings—in case you want to make an exposure of several seconds.

Be sure to buy the most stable tripod within your budget and one you are able to carry. A heavy tripod will offer better stability than a lightweight model, but if it is too heavy, you are unlikely to carry it around.

If you want support without having to compromise portability, then invest in a monopod. This single-legged gadget is perfect for photographers on the move who want to travel light but still want to minimize the risk of camera shake.

It is also worth having a small table-top tripod in your camera bag—just in case. The Gorillapod's unique design allows its legs to be wrapped around a tree branch or a fence post and provides good camera stability.

REMOTE RELEASE

An optional remote release lets you take pictures without touching the camera and risking camera shake. Remote releases range from simple devices with a shutter button to more advanced units that allow you to take time-lapse shots.

WHITE-BALANCE DEVICES

Most DSLRs have a custom mode so you can program a white-balance reading taken with an external white-balance device. This ensures you get the best possible white-balance performance for the prevailing lighting conditions. This is especially important if you shoot in JPEG format. Unless you are a product photographer, it can be considered a luxury, since your camera already has automatic white-balance (AWB).

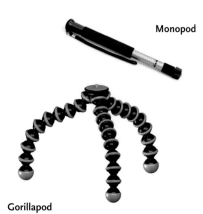

Monopod

Gorillapod

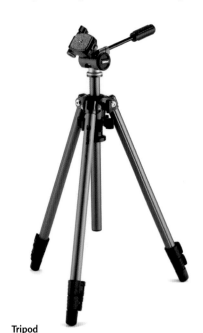

Tripod

PORTABLE STORAGE DEVICES

With the prices of camera memory storage cards coming down, it is now possible and affordable to accumulate enough memory cards for short trips. Consequently, portable storage devices are not as crucial as they were a short while ago. However, a portable album is still an important backup, because cards can be lost or corrupted. Some are also handy as viewing devices so you can check your pictures while you travel.

The devices are available in a variety of different sizes, such as 40GB, 60GB, or 80GB.

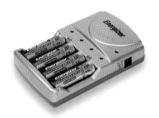

BATTERY CHARGER

Save money by buying a battery charger and a few packs of rechargeable batteries. Go for cells with a rating of 2300mAh or more. Many units can also be charged in a car's cigarette lighter socket, which is useful when on the road.

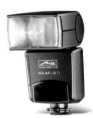
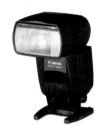

SEPARATE FLASHGUNS

Flashguns are available from well-known camera brands as well as independent manufacturers.

There is often a flash built into your camera, but it is useful only for subjects up to approximately 10 feet (3m) in distance. Any further and its effectiveness is limited, so a separate flashgun is recommended.

A separate flashgun is more powerful and offers greater versatility. It can also be used off the camera—with an appropriate lead—for greater modeling. Moving the flashgun away from the lens axis helps to minimize the red-eye effect.

The more you spend, the more you get. Buy a top-end flashgun and you receive power, plenty of features, and versatility. You may not need such an advanced unit, but even a modest flashgun will have enough power for most users. Plus, it has bonus features, such as a bounce and zoom head, adjustable output, and fast recharging.

STORAGE BAGS

You need a protective bag to carry your camera, lenses, and accessories; there are two main types to consider.

A camera outfit comprising a DSLR, an extra lens, and a few filters will easily fit into a typical over-the-shoulder bag. Most bags will also have pockets to stash memory cards and spare batteries. Shoulder bags are perfect for use around town when you want to find things quickly, and they are comfortable to carry.

Another option is a photo backpack. Although it is not at your fingertips, it is more comfortable because the weight of the camera outfit is spread evenly across your back, and both hands are free.

Photo backpacks are often used by outdoor photographers because of the large amount of equipment they have to carry around.

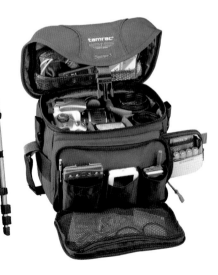

Digital darkrooms

A computer is not an essential tool for digital photography, but it helps a great deal. Although digital cameras do a wonderful job of producing sharp, beautifully exposed pictures, their enhancement capabilities are limited. Computers enable you to greatly improve your photos before printing and e-mailing them to friends and family. This in turn will enhance your enjoyment of digital photography and give you complete control of your pictures.

MAC OR WINDOWS?

If you bought a computer within the past few years, it should be more than powerful enough for digital imaging. As a first step, you need to make sure it meets the minimum operating requirements of any software you want to install, but this can easily be checked.

If you are shopping for a computer now, there is a wide range of computers available, and most of them are suited for digital photography.

One decision you will have to make is whether to buy a computer that runs Microsoft Windows or an Apple Macintosh or Mac. Macs are excellent machines for imaging, and they are used by many professional photographers; however, Windows computers are more common, and there is more software available. It is a matter of personal preference, but ideally you should try both systems before buying.

WHAT TO LOOK FOR

Whichever computer system you choose, three key things to keep in mind are processor speed (measured in GHz), RAM (Random Access Memory), and hard-drive capacity (both measured in gigabytes). Briefly, the faster the processor, the more

Keep yourself organized

As you begin to accumulate pictures, it becomes more crucial to keep track of them. There is nothing more frustrating than not being able to find pictures when you want them. Maybe you have deleted them by mistake or stored them in the wrong place.

An organized workflow will avoid these annoying disasters and enable you to find your pictures quickly.

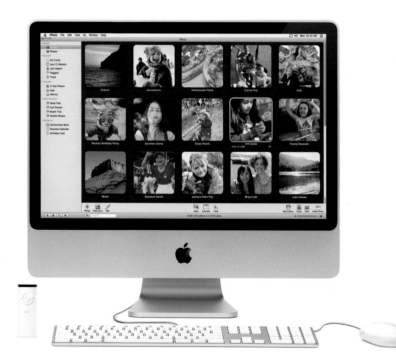

An Apple iMac computer system provides all of the tools you'll need to download and edit your digital photographs.

quickly things happen. The more RAM on your computer, the more applications you can have open and the faster they will work. Look for at least 512 MB (0.5 GB) RAM, but 1 GB is better. Keep in mind that the greater the hard-drive capacity, the more programs and images you can store. A hard disk of at least 80 GB is recommended, but 120 GB or 160 GB is preferred.

Most computers are sold with a monitor screen, usually an LCD (liquid crystal display) flatscreen. This type of screen takes up less space and provides excellent color and contrast. A few years ago computers came with CRT (cathode ray tube) screens that were heavy and took up much more space.

You may be surprised, but even fairly modest modern computers will suit the avid photographer and allow for a high level of digital manipulation. That's partly because a lot of recent development in computer technology has gone into handling high-definition video—displaying many high-quality images in quick succession—so the ability to display static photos, even of high resolution, is almost a given.

A Microsoft Windows–based computer system comes with different tools depending on the version of Windows included.

Desktop or laptop?

If you are trying to decide between a desktop or a laptop, the desktop machine is arguably the better option. It will bring you more value, with a faster processor, more RAM, more hard-drive space, and a larger, better-quality monitor for the same money.

Of course, laptops are more convenient. Perhaps in the long term, you could use a desktop machine for all your usual photographic work and a laptop when working away from home and while traveling.

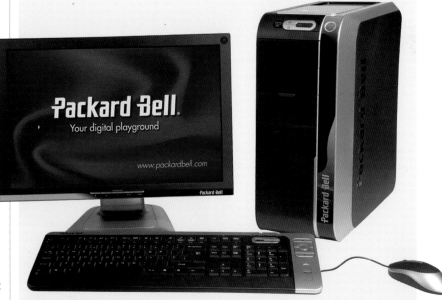

Digital darkroom accessories

At the center of the digital darkroom is the computer; it is the hub of your imaging operations. Aside from software, you could argue that a computer is all you need, but that would be no fun at all.

There are many optional accessories for the digital photographer to consider. Some will make your life easier, while others are just plain indispensable. Whether you consider the items on this page to be nice luxuries or absolutely vital is up to you—and how involved you want to get.

MEMORY CARD READERS

You can transfer images from your camera by connecting the camera to your computer using the manufacturer-supplied cord. Many experienced photographers, however, prefer using a card reader. They are relatively inexpensive, and models are available that will accept several memory card formats. This is very convenient if your family uses cameras with a variety of storage cards. Card readers are available with USB 2.0, FireWire 400, and FireWire 800 connections.

DVD BURNER

Most desktop and laptop machines have built-in CD/DVD burners. However, with dual-layer DVD technology available, you may need an external recorder to make the most of this technology. A dual-layer DVD has a capacity of 8.5 GB compared with 4.7 GB of a standard DVD.

Hubs for extra connectivity

It is awkward and time-consuming if you frequently need to unplug your computer peripherals, especially if you do not have much workspace. A hub will provide several connection interfaces from just one lead plugged into the computer. It is definitely a useful gadget—USB 2.0 and FireWire versions are available—and it is generally fairly inexpensive.

It is worth noting, however, that some devices do not work well through a hub. Data-transfer speed can be slower than a direct connection since the same total bandwidth to the computer is shared between devices.

COLOR MANAGEMENT

Profiling your computer monitor with a colorimeter will help you receive prints that consistently match the image on your display. Most work on both CRT (cathode ray tube) and LCD (liquid crystal display) monitors, and they are fairly straightforward to use following the on-screen instructions.

Card readers, hard drives, and printers connect to the computer through special leads. These are the three interfaces currently used by DSLRs.

USB 2.0 Hi-Speed. This supersedes USB 1.1, and it is probably the most popular interface used today. Its maximum data-transfer rate is faster than USB 1.1, but the connectors are the same. A USB 2.0–equipped computer still works with older devices, too.

FireWire 400. This is a popular interface on Macs and Windows machines. Maximum transfer rate is 400 MB per second. FireWire 400 is available with four- or six-pins.

FireWire 800. This interface is found on high-end devices and Mac computers. The maximum transfer rate is 800 MB per second, nearly twice that of USB 2.0, making it popular with video experts. It has a nine-pin connector socket.

PORTABLE FLASH DRIVE

A high-speed flash drive is a small, low-cost, plug-in memory device that lets you conveniently carry photos around. They can hold anywhere from 8 MB to 32 GB of data. Most are USB drives, often called sticks.

If you want to transport more information, a compact hard drive is recommended. This small package will bring a large amount of memory to your disposal.

GRAPHIC TABLETS

When you become more advanced using image-editing software, this penlike device—which works in conjunction with a touch-sensitive pad—is worth its weight in gold. It is especially useful for making precise selections in image-editing software. Many photographers prefer to use a graphic tablet instead of a mouse, because there is less risk of repetitive strain injury (RSI).

External hard drives

Whatever size you choose, an external hard drive is the best way to avoid clogging your computer's main hard drive. You may even need two. After all, if your entire collection of digital images is sitting on your computer's hard drive and it fails, there is the real risk of losing all of your invaluable pictures.

Depending on your system, it might be possible to add an extra internal drive to the computer and set it up to automatically back up the main drive. However, an external backup system is still advised.

External hard drives come in a range of capacities, but a 250 GB or 320 GB drive is a good start. The larger drives are heavier and usually require an external power supply.

Many photographers do not appreciate the importance of archiving their images until they lose pictures due to technical failure or carelessness. Preemptive measures will prevent a great deal of anguish and heartache.

Home photo printers

If you used to shoot your pictures on film, then you are familiar with having printed photographs in hand.

Although digital photographers can enjoy their pictures on-screen immediately, there is nothing like having a beautiful print in your hands to reward your photographic efforts.

MANY PATHS TO PRINT

There are several ways to get prints. Your local photo store or processing lab will readily accept memory cards and CDs and be able to produce prints from your image files. Plus, many retail stores have photo kiosks where you can enhance and crop your photographs before outputting them.

Online processing laboratories are another option. These companies ask you to upload picture files to an Internet site and then allow you to choose from a wide range of printing services before mailing you the results.

However, while these printing options will deliver convenient top-quality results, there is nothing as satisfying and rewarding as producing prints at home on your own printer.

Media options

One of the beauties of ink-jet printing is the huge range of different printing papers available. Whether you prefer high gloss, the toothy finish of luster, or the tactile qualities of a textured art paper, inkjet printing is compatible. Art finishes are especially attractive and give your images a touch of individuality.

Even though digital photo frames have gained in popularity, paper prints have not lost their appeal.

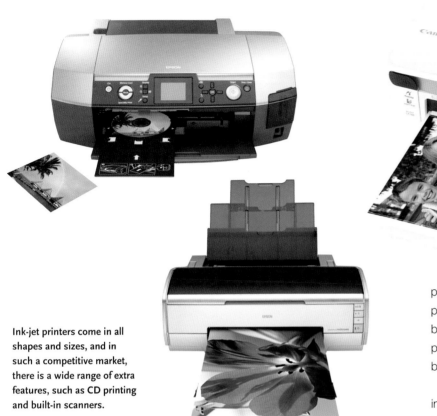

Ink-jet printers come in all shapes and sizes, and in such a competitive market, there is a wide range of extra features, such as CD printing and built-in scanners.

PRINTER CHOICE

There are two types of home-photo printer technology. Dye-sublimation (dye-sub for short) thermal printers, or ink-jet printers.

DYE-SUB

There are many dye-sub models available for home use. Some models are battery–as well as outlet power–operated, so you can print pictures away from home.

Dye-sub printers produce excellent quality prints, but they are expensive to run. A dye-sub printer uses a special cartridge that has four printing color dyes—magenta, yellow, cyan, and black—impregnated onto a roll of transparent film. As each print is made, a heated print head vaporizes the dyes and transfers them onto the paper surface, where they solidify.

There are some disadvantages, though; besides the high cost, the printers are usually only large enough to produce 4 × 6-in. prints.

INK-JET

For versatility, the ink-jet printer is king. An ink-jet printer uses tiny nozzles in a print head to lay incredibly small droplets of colored ink onto the printing surface. Photo-quality ink-jet printers use several colors for the best results, because it is easier to print lighter colors. However, they can be supplied in a single cartridge.

In terms of output sizes, most home ink-jet printers can produce prints at U.S. Letter or European A4 size, with a few models offering tabloid-size (A3+) output.

Most home ink-jet printers have to be connected to a computer, but a few models accept memory cards for direct stand-alone printing. Some may even allow some basic image-editing functions, such as cropping and red-eye removal.

There has also been a trend for manufacturers to develop multi-function units that combine fax, scanning, and printing capabilities. Although the printing function of these units is not usually up to the quality of dedicated printers, it is still good enough for most needs.

Image-editing software

You can enjoy digital photography without software simply by viewing your pictures on a TV. Most avid photographers, however, will use software to edit their results, produce presentations, create Web sites, and much more.

A software package is usually supplied with a new digital camera, although its functionality may vary depending on the model and manufacturer. If you shop for software, you will be confronted by hundreds of packages, all promising great things.

CHOOSING YOUR PACKAGE

The most important software investment you will make is the package you choose to edit and manipulate your photographs. The best-known image-editing brand is Photoshop. The full package—sold alone or as part of Adobe's Creative Suite—is used by imaging and graphic arts professionals. Photoshop Elements is a related package aimed at hobby photographers, and it is certainly powerful enough to satisfy most needs. It has all of the key features that will enable the main image enhancements, such as levels and cloning. Plus, there is a wide range of creative features, including layers and selection tools that will let you work on specific areas of the picture.

Although Photoshop is one of the more well-known programs, other options include Corel PaintShop, Pro Photo, and Ulead PhotoImpact.

Plug-ins

Plug-ins are extra pieces of software that extend the capabilities of another tool. Over the years, a new industry has sprung up that produces plug-ins that are compatible with the family of Adobe Photoshop products. Plug-ins offer a wide range of useful functions to improve and enhance your photographs. Among the hundreds available, there are plug-ins to add creative frames, make masks, resize files, provide giant enlargements, and make digital images look filmlike.

However, you are the best judge of whether a plug-in is useful. Free demo downloads are usually available so you can try it before you buy.

If you find a plug-in you like, make sure that it is compatible with your software.

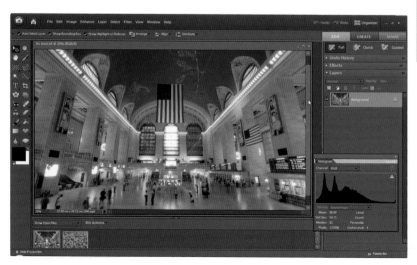

Here, a picture is being edited in Photoshop Elements. You can see different tools in the Toolbox along the left of the screen, options relating to the selected tool in the *Tool Options* bar above the image, and panels on the right that can display information about the picture and allow you to choose from and apply effects.

Presentation software

Making slide shows of your images can be rewarding, and it allows you to share your work with family and friends. Creating these presentations is possible in some image-editing tools. However, dedicated programs can offer more features, such as trick fades and adding a soundtrack. Afterward, the software will allow you to write to a CD or DVD for replay on a computer or a domestic DVD player.

Raw processing

Shooting in Raw format—a file format that stores all the data that is recorded from the image sensor and camera meters—can give you the best possible image quality from a digital camera. Raw files also offer great flexibility in terms of modifying exposure and white-balance. However, proprietary Raw format files cannot be enhanced and manipulated until they have been processed or developed into JPEG or TIFF files.

Raw converters usually offer more features than straightforward image processing.

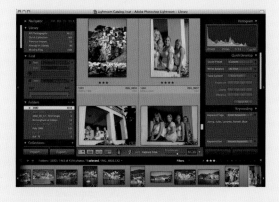

Digital asset management

Once you start shooting digital images, you will rapidly gather a sizable file collection. Keeping track of your digital pictures can be time-consuming, so it is worthwhile to invest in Digital Asset Management (DAM) software. There are many packages available that allow you to name pictures, make catalogs, and search through your pictures. Some packages will also handle the work of Raw processing.

Understanding
Your DSLR

2

Setting apertures

To achieve the correct exposure, the right amount of light must reach the camera's imaging sensor. Too little and you get very dark, underexposed shots; too much, and your overexposed pictures will be too light. The aperture and shutter speed are the two settings that control how much light reaches the sensor—and they are inextricably linked.

LETTING LIGHT PASS

Simply put, the aperture is the hole in the lens that lets light through to the sensor. The lens aperture, or hole size, is expressed in f-stops—$f2.8$, $f4$, $f5.6$, $f8$, and so on. The lower the number, the wider the aperture, and the more light that passes through.

There is a simple relationship between f-stops. In the sequence below, $f5.6$ lets through twice the amount of light as $f8$ and half the amount as $f4$. On traditional, older camera lenses, the typical sequence of f-stops is $f2$, $f2.8$, $f4$, $f5.6$, $f8$, $f11$, $f16$, and $f22$. There is a whole "stop" difference between each value. Modern cameras have accurate half- or third-stop values. The one-third steps between $f5.6$ and $f8$ are $f6.3$ and $f7.1$.

Aperture doesn't just affect light. A wide aperture reduces the "depth of field." This is the amount of front-to-back sharpness. Less depth of field means that the area you have focused on is sharp, but the foreground or background is soft.

 LENS LINGO

There is plenty of photography jargon when it comes to lens apertures. Here's what the terms really mean.

One-third or half f-stops. The incremental settings between whole f-stops.

Open up. Setting a wider aperture value—for example, $f5.6$ instead of $f8$.

Close or stop down. Setting a smaller aperture value.

Fast lenses. Lenses with relatively wide maximum apertures. For example, a 24-mm $f2$ lens is faster than a 24-mm $f2.8$.

Slow lenses. A lens with a relatively modest maximum aperture for its focal length.

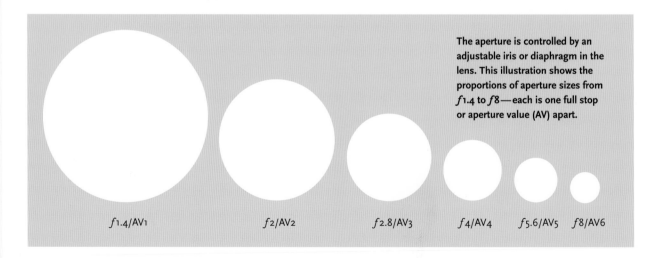

The aperture is controlled by an adjustable iris or diaphragm in the lens. This illustration shows the proportions of aperture sizes from $f1.4$ to $f8$—each is one full stop or aperture value (AV) apart.

$f1.4$/AV1 $f2$/AV2 $f2.8$/AV3 $f4$/AV4 $f5.6$/AV5 $f8$/AV6

If you shoot at a small aperture (such as ƒ16 or ƒ22), you will get greater depth of field. Therefore, more of the scene, from the near foreground to the distant background, will be in sharp focus. You can check this using the camera's depth-of-field preview.

With this function, you can see the effect of different apertures in real time. Focus on a subject that is near the camera but in front of a distant backdrop. Look through the viewfinder, and you will see the scene at the lens's widest aperture. Make a mental note of the relationship between the subject and the background, which should be blurred and out of focus.

Now change the aperture value to ƒ16 and look through the viewfinder again, while operating the depth-of-field preview. The viewfinder image will darken, so allow your eye a few seconds to adjust to the dimmer image. You will notice that the background is much sharper.

The approach you choose generally depends on what you are photographing. A landscape benefits from an extensive depth of field so that the entire subject is sharp. A portrait works well with a shallow depth of field because the sitter will stand out from a soft background.

Bear in mind that changing the aperture also means adjusting the shutter speed, or ISO, to compensate (see pages 34 and 42). If you choose a longer shutter speed, you may need a tripod to avoid camera shake.

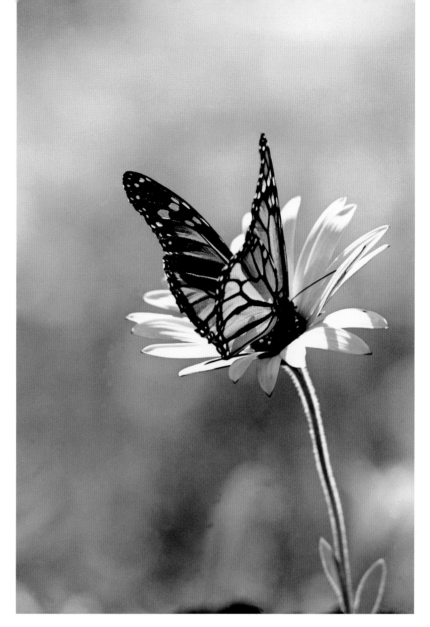

BUYER'S GUIDE

You will often see lenses quoted in the format 70–300 mm ƒ4–5.6. This means that it is ƒ4 at the 70-mm focal length range and ƒ5.6 at 300-mm. It is proportional between focal lengths.

A wide aperture gives a very shallow depth of field, so the background is nicely blurred while the subject remains in sharp focus. In this example, taken with a very fast ƒ1.2 lens, only the butterfly's wings are in focus. When you set a wider aperture, it is necessary to reduce the shutter speed to compensate; in poor light setting a wide aperture is likely the only way it will be possible to have a shutter speed short enough to avoid camera shake.

Setting shutter speeds

The shutter speed determines how long the imaging sensor is exposed to light. The shutter is, in a sense, a lightproof cover that unveils the sensor behind it when the release is fully pressed. While the shutter is open, light falls onto the sensor to make the exposure.

Shutter-speed choice goes hand in hand with aperture selection. If you start with the settings that will lead to a correct exposure and then change either the aperture or shutter speed, you must change the other or your image will no longer be in focus.

CHOOSING A SHUTTER SPEED

Most pictures taken at 1/125 sec to 1/250 sec will provide sharp pictures when the camera is handheld. These speeds are a good compromise between stopping any subject movement and mid-apertures for reasonable depth of field.

However, with such a wide range of speeds available, you have the option to try different speeds for particular subjects.

To stop any fast-moving action, a high speed such as 1/1000 sec or even 1/2000 sec is essential, although you will need to take the action into account. A person jogging toward you can be "frozen" with a modest speed such as 1/60 sec, while a racing car speeding by you will need 1/1000 sec or more.

At the other extreme, longer shutter speeds are needed for subjects like night scenes and for producing deliberate blur effects in daylight, such as flowing water in a waterfall.

Be sure to remember that the shutter speed and aperture are inextricably linked. If you change one, the other must change, too. For example, if you need to set a longer exposure to create a blur effect, you should set a correspondingly smaller f-stop. Since $f8$ is half the light of $f5.6$, this will allow you to double the time the shutter is open.

Impressions of speed

Moving subjects can be portrayed in a variety of ways through careful shutter-speed selection. For example, panning is tracking a moving subject through the viewfinder and then pressing the shutter release during the pan. If the technique is done right, the result is a reasonably sharp subject against a blurred, streaked background, giving the impression of speed.

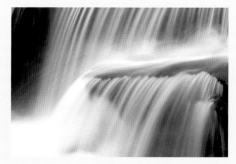

1 second

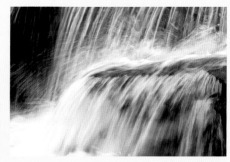

1/20 sec

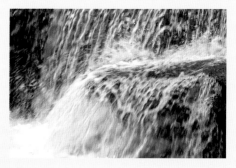

1/80 sec

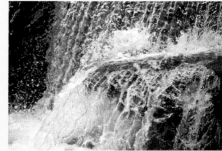

1/640 sec

Your shutter-speed choice can result in very different interpretations of the same scene. For example, this waterfall cascade was photographed at a selection of speeds. There is no right or wrong approach; it is simply a matter of taste. Any scene that features movement can be approached in this way.

Staying informed

Whether you are just starting out or you've been taking photos for years, understanding the mechanics of your camera and its various settings is essential for achieving the very best photos. With modern cameras, keeping informed has never been easier, thanks to a variety of built-in devices.

THE VIEWFINDER

A camera's viewfinder is its mission control center. This is where you compose your pictures. The bright image seen through the viewfinder enables accurate composition and focusing, but there is so much more to appreciate and digest. You are provided with up-to-the-moment camera-setting data, so while you are composing your pictures, any necessary changes can be applied quickly.

In fact, experienced photographers can make vital changes without taking their eye from the viewfinder eyepiece, so they never miss a photo opportunity. For newcomers to DSLR photography, this is an excellent skill to master, especially for making basic changes, such as adjusting the aperture and shutter-speed values. Changing the ISO sensitivity, autofocusing zone, or exposure compensation is less important. These abilities may come with practice or might be impossible without looking at the on-screen menu.

 TOP-PLATE LCD

The LCD panel on the camera's top plate repeats some of the information found in the viewfinder and rear monitor, but there are usually more details included. Apart from exposure settings, you see white-balance, exposure mode, metering pattern, battery conditions, image quality, and drive settings. Some DSLRs have an illuminated top plate so it is possible to check your settings in the dark.

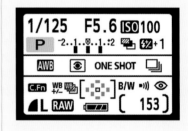

BUYER'S GUIDE

Seeing the screen can be an issue in bright sunlight. An accessory monitor shade is available for many camera models that helps to keep direct sunlight off the screen. When the screen is not required, the shade is folded down so it is not in the way.

When open, the monitor shade keeps direct sunlight off the screen.

It easily snaps closed when not in use.

Viewfinder readout

Keeping an eye on the viewfinder information panel and the camera settings will help you take better pictures. For example, if the shutter speed is slower than you want, adjust the aperture to a wider value. This will allow more light to come through the lens to provide a faster shutter speed to take sharp pictures.

The typical viewfinder also has plenty of other functions, as well as box outlines, to indicate the target areas of the focusing sensors. The relevant focus-point outline lights up to indicate that it is active. Multiple sensor autofocus systems usually allow the user to select which sensor they want to be active.

Most DSLR viewfinders show approximately 92–95% of the actual image, so do not be surprised when you see more of the scene included in your photos. Only a few high-end professional DSLRs show 100% of the actual image. A few models also have the option of interchangeable viewfinders so that different eyepieces can be attached.

Rear monitor

The rear LCD monitor is mostly used to review pictures, and a magnifying function is provided to closely check image sharpness. There is usually a histogram function to check the exposure.

If you push the menu button, a whole host of user settings appear. Many of these menu items, such as color space, can be left alone after the camera's initial setup. Others will come into play only in specific shooting situations. You may, for instance, want to engage the mirror lock-up for night photography.

Navigating the menu system usually takes some familiarity, so simply accessing it and seeing which functions are available is a good idea.

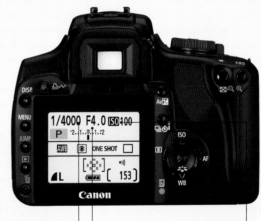

Shutter speed
Here the shutter is set to 1/4000 sec.

Aperture setting
Indicates the current aperture setting is ƒ4.

ISO setting
Indicates the selected ISO setting is 100.

Focus sensor
Indicates a focusing sensor's target area, and the tiny light in the center indicates whether the sensor is in use.

Aperture setting
Indicates the current aperture setting (ƒ5.6).

Shutter speed
Indicates the selected shutter speed (1/125 sec).

Exposure compensation
If you set the compensation function to add or detract from the camera's automatic setting, it is indicated here. Here it is set to +1.

Keeping in sharp focus

Focusing can be simple. The camera's autofocus depicts a sharp image in the viewfinder so you can shoot away without worry. It can be that straightforward, but to develop your camera skills, it helps to understand more about this key aspect of photography, especially when you have to lend a hand.

If shooting at a wide lens aperture with a telephoto lens, focusing is critical. Make an error of a few inches and you will be disappointed with the result. With a scene like this, using just the central focusing point ensures that the camera focuses where you want it to.

AUTOFOCUS SYSTEMS

Every DSLR has a sophisticated automatic focusing (AF) system that is very effective in most lighting conditions and with most subjects.

Autofocus systems in SLR cameras work by using a number of contrast-detecting sensors. Each sensor is called a charge-coupled device (CCD). This measures the contrast of the actual picture elements or pixels within the scene. An out-of-focus scene has adjacent pixels of similar values. The camera's computer will adjust the lens focus motor until it achieves the maximum contrast between adjacent pixels. This is the point of sharp focus.

Modern AF systems can focus in conditions where the human eye struggles. However, AF systems need

light and contrast to operate. If it is dark, or if the colors within a scene are almost identical, even the world's best system will not be able to detect any contrast difference. Therefore, the system will search, or hunt, back and forth. In these situations you will have to focus manually.

THE MORE THE MERRIER

Modern DSLRs have many sensors, or focus points, that are strategically positioned around the picture frame to enable autofocus on complex scenes and fast-moving and static subjects. Generally, the more expensive the camera, the more sophisticated the AF system. For example, the professional Canon EOS 1DS Mk III has 45 focus points, while the consumer-level Canon Digital Rebel (EOS-450D) has nine.

Additional autofocus sensors can help overall AF performance and accuracy. Ironically, many experienced photographers set up their camera with only the central focusing sensor active. One problem with having many focusing zones active is that the camera can lock onto part of the scene that you do not want in focus. This can happen in crowd scenes where there are people positioned at varying distances from the camera. If just one sensor is active, you will know precisely where the camera will focus.

One feature that every camera has is autofocus lock (AF-L). This may be located on a separate button, but it also functions by partially depressing the shutter release when the camera is in single-shot (or one-shot) AF mode. It takes a little practice to depress the shutter release to lock focus without taking a picture, but the point where the shutter trips is usually well defined.

The most recent focus innovation is face detection. This feature recognizes human faces within the picture and will set the focus and exposure to ensure that the faces are shot correctly.

📷 FOCUS MODES

DSLRs offer several focusing modes, as well as the option to change active focus points. Focus confirmation is provided in the viewfinder, and it is also denoted by an audible beep.

Many cameras have a version of single-shot autofocus that will adjust the focus if movement is detected by the sensor.

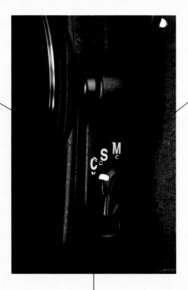

In single, or one-shot AF (S), pressing the shutter release halfway down will focus the camera on the subject. The picture is taken when the release is fully depressed. The focus is locked, even if the subject moves, as long as the shutter release is held partially down.

In manual focusing (M), the AF motor is disconnected, and all focusing is done by rotating the lens's focusing barrel. A focus confirmation signal appears in the viewfinder.

In continuous, predictive, or servo AF (C), the camera continually tracks the focus if the subject moves. It is ideal for moving subjects.

Understanding exposure modes

There is so much technology packed into the modern camera that you can literally point and shoot and receive excellent pictures without getting too technical with the settings.

 Finding the correct exposure is a good example. Every DSLR has an array of exposure modes, coupled with a variety of ways to measure light. You can either keep things simple or get very involved and thus more creative. The choice is yours.

The dial below is a camera's exposure-mode control. Depending on your camera, you may have several more functions, but the ones discussed below are crucial in creative digital photography.

Manual metering (M)
This allows you to choose both aperture and shutter speed-settings, in conjunction with a meter readout in the viewfinder or a separate handheld light meter. Use this mode to be in control.

Auto Depth of Field (A-DEP)
This mode is similar to aperture priority but automatically sets an aperture with a depth of field that will keep all of the autofocus points in focus.

Aperture-priority AE (Av)
In this mode, you pick the aperture and the camera sets the shutter speed to give the correct exposure. Use when your aperture setting is very important. For example, shooting a landscape with a small aperture ensures extensive depth of field.

Shutter-priority AE (Tv)
This is similar to aperture-priority AE. However, this mode allows you to set the shutter speed, and the camera picks the aperture to give the correct exposure. Use this when shutter speed is extremely important. Action shoots are a good example.

Subject modes
Subject modes do more than just set exposure. They also set the parameters for drive, ISO, flash use, and metering patterns. Portrait, landscape, action, and close-up are popular subject modes. Some cameras include night portrait, sunset, and beach scene modes, too.

Program AE (P)
This is a true automatic exposure mode because the camera sets both the aperture and the shutter-speed value according to the lighting conditions. There may also be a program shift function, which allows you to change camera settings while retaining the correct exposure level to suit what you are shooting.

Green square mode
This mode prepares the camera for point-and-shoot capability. The camera controls exposure, drive speed, image quality, and ISO, so there is nothing for the user to worry about. It is convenient, but it limits creativity.

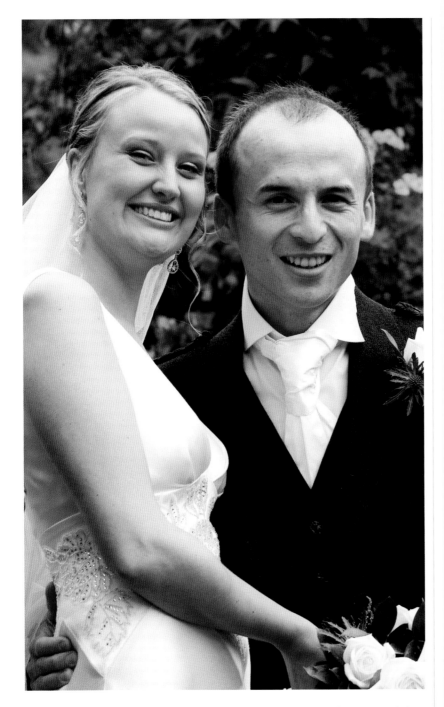

There will be times when concentrating on the scene in the viewfinder is much more important than the technical side of photography. For example, a point-and-shoot autoexposure is ideal for family occasions such as weddings.

Metering patterns

In addition to choosing an exposure mode, you also need to decide how the camera will measure the light entering the lens. Modern cameras have a variety of options.

• Multiple-segment metering

is arguably the best mode for the majority of the time. Camera makers have their own brand names for multisegment or multizone metering, such as Matrix, Evaluative, and Honeycomb. In each case a sensor takes light measurements from different areas of the scene, depending on how the zones have been configured. The camera's computer analyzes the data from each segment and provides an exposure based on that assessment. They are generally reliable and produce consistent results.

• Center-weighted metering

measures light from a large part of the image area. However, it biases toward the center bottom half of the viewfinder, so these areas are more likely to be exposed correctly.

• Spot/selective metering

lets you measure light from a small area of the image. It is usually depicted in the viewfinder by a circle outline. Some experienced photographers prefer spot-meter readings, which need to be done carefully.

What is ISO?

Photographic film is sold in a range of sensitivities to light, and this is expressed as an ISO rating. Of course, digital cameras do not use film, but their imaging sensors have a spectrum of sensitivities that are broadly equivalent to conventional film.

A low ISO number (50, 100, 200) means a lower sensitivity to light and therefore longer exposures. Conversely, a higher ISO number (800, 1600, 3200) equals a greater sensitivity to light, which allows for shorter exposures.

This picture was captured at ISO 100 (1/80 sec). A series of increasing ISO values (and correspondingly shorter shutter speeds), resulted in an increase in grainlike noise.

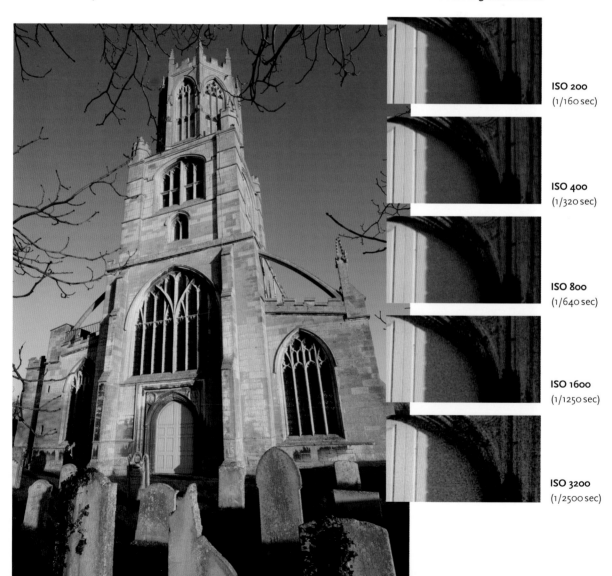

ISO 200
(1/160 sec)

ISO 400
(1/320 sec)

ISO 800
(1/640 sec)

ISO 1600
(1/1250 sec)

ISO 3200
(1/2500 sec)

WHICH ISO TO USE

A typical DSLR will have a minimum ISO setting of 100 and a maximum of 1600, with speeds of ISO 200, 400, and 800 in between. More advanced DSLRs may have a broader range, which includes smaller intermediate steps, or higher maximums.

There is a direct relationship between these ISO speeds. For example, ISO 200 is twice as sensitive, or "fast," as ISO 100, but half that of ISO 400. In terms of actual exposure settings, while ISO 200 may allow a shutter speed of 1/125 sec, this would halve to 1/60 sec at ISO 100 or double to 1/250 sec at ISO 400.

Generally, the lowest ISO setting of a DSLR is the sensor's base sensitivity, and faster speeds are obtained by electronically amplifying or boosting the image. In a similar way to film, optimum digital results are obtained at the lower ISO speeds, which result in superior color saturation, sharpness, and better resolution of fine detail. There is also minimal digital noise, and areas of even tone remain smooth.

A modern DSLR will show little or no noise at ISO 200 and slower. However, from ISO 400 and higher, the images will begin to look less impressive and exhibit digital noise, especially in smooth-toned shadow areas. The look and severity of noise varies depending on the camera. It appears as colored mottling, and it will be very obvious at high sensitivities such as ISO 1600 and 3200.

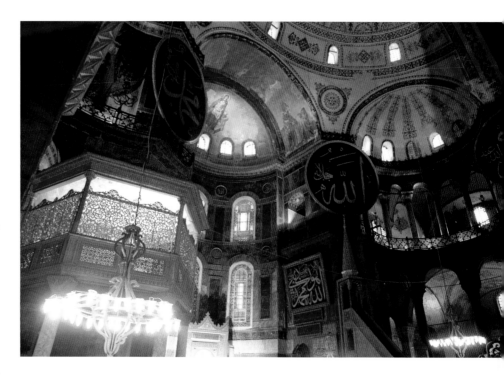

QUALITY MATTERS

To achieve the best possible image quality, you want to use a low ISO rating. However, this is often determined by lighting conditions.

For a dimly lit interior or when shooting on a cloudy day, a medium ISO of 100 or 200 might not be fast enough to avoid camera shake or subject movement. Setting a higher ISO sensitivity is necessary for sharp pictures, but that also adds noise.

Knowing which ISO sensitivity to set in particular conditions comes with experience, so some cameras can assist you with an automatic ISO function. This leaves it to the camera to set an appropriate ISO sensitivity for the prevailing light conditions. When the sun is shining, the camera

A mosque interior with light and dark areas. It's possible to see sections of noise in the dark areas of the picture.

will set a medium ISO. But when the sun disappears behind a cloud, the camera will automatically choose a higher sensitivity. On some models it is possible to set limits in which this auto ISO function works. So instead of having auto ISO working within the entire range, you can restrict it to, for example, ISO 100 to 400.

At the fast end of the ISO range, some DSLRs offer ISO expansion. This sets an ISO beyond the camera's default range. It is often included as an extra menu item rather than part of the camera's standard features, because the image quality is very noisy.

Choosing image resolution

The resolution of every digital camera is expressed in millions of pixels, or megapixels. As a general rule, the more pixels, the better in terms of overall image quality. However, there are many other variables that come into play, too. As well as the sensor, the camera's image-processing circuitry and the lens are just a few of the factors that influence your final photo quality.

Major strides have been made in sensor resolution, and modern DSLRs start at 6 megapixels for a consumer model; professional models offer two or three times that resolution. How much you actually need depends on your photographic ambitions. However, it is fair to say that even a modest 6-megapixel DSLR can easily give true film-quality enlargements of Tabloid or A3-size (29.7 × 42 cm) and bigger.

Shooting a high-resolution image file will give the best possible quality file available. You can reduce the size later, such as for Web or e-mail, but you cannot scale an image up and increase detail. So unless you are really pushed for storage space, always try to shoot at the highest pixel resolution available. This will also give you better-quality results because one pixel on the image

What is resolution?

The resolution of an imaging sensor is defined as the number of individual light-sensitive picture elements (pixels) that it contains. The Canon Digital Rebel's sensor, for example, has 2592 pixels across its width and 3888 pixels along its length. Multiplying the two figures gives the file resolution of 10.1 million pixels, or 10.1 megapixels.

Cameras often quote a total pixels (10.5-megapixels in the case of the Rebel) figure and an effective resolution figure. It is the latter that is important because it is only those pixels that are used to produce the image.

📷 HOW MANY PICTURES DO YOU GET?

The chart below lists the number of photos you can fit on a memory card, assuming a 2-GB capacity and an 8-megapixel DSLR. This is only a guide, because the actual capacity varies according to the type of pictures you are shooting. Images with plenty of detail and shots taken at higher ISO speeds use more memory than simple images or those exposed at lower ISO sensitivities.

File type	File size	Image size	Number of photos
Small JPEGs	0.8 MB	1936 × 1288 px	1479
Medium JPEGs	1.5 MB	2816 × 1888 px	862
Large JPEGs	2.8 MB	3888 × 2592 px	516
Raw	8.4 MB	3888 × 2592 px	200
Raw + Large JPEGs	12.5 MB	3888 × 2592 px	111

sensor will translate to one pixel in the image, with no extra processing taking place on the picture information.

Pixel resolution is only one of your choices, however. Another is the type of file you want to store and its level of quality. This boils down to JPEG and Raw, which is essentially a decision between setting the picture in stone as you shoot, or preserving as much information as possible for digital editing. You can change JPEGs in photo-editing software, but Raw will give you the most flexibility.

JPEGs use "lossy" compression, which discards image information the eye can't really discern. With settings such as JPEG Large, the difference is very hard to spot. But if you choose the smallest option your camera offers, you may see funny marks, or artifacts, in your photos—especially around areas of detail.

On the other hand, Raw stores everything the camera records, which means every camera model has its own type of Raw file. While JPEG files are universally accepted, you will usually need to install special software on your computer to open Raw files. This software will often come with the camera, though some third-party programs can also read major manufacturers' Raw files. Photoshop Elements, for example, has a Raw converter tool.

Note that Raw is a generic term and that different manufacturers' Raw files will be denoted by different file extensions, such as .CRW for Canon or .NEF for Nikon.

Relative Resolution

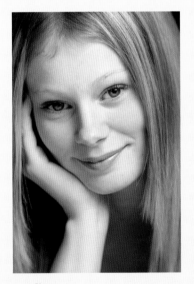

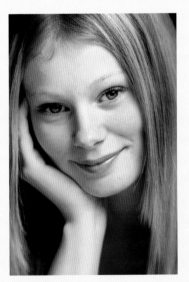

Raw file
3888 x 2592 pixels
Print size: 12.9×8.6 in. (32.9×21.9 cm)

Fine-quality JPEG
3888 x 2592 pixels
Print size: 12.9×8.6 in. (32.9×21.9 cm)

Normal-quality JPEG
2816 x 1877 pixels
Print size: 9.4×6.3 in.
(23.8×15.9 cm)

Small-quality JPEG
1932 x 1288 pixels
Print size:
6.4×4.3 in.
(16.3×10.9 cm)

These portraits—taken at four different quality levels—are shown at their relative sizes, assuming they were printed at a resolution of 300 pixels per inch (ppi).

Getting the right color

The human brain is an amazing feat of biological engineering. If you look at a typical scene, your brain will tell you if it is the right color. The sophisticated circuitry inside a digital camera's white-balance feature plays the part of the human brain. It deals with the constantly changing lighting conditions to ensure that pictures come out accurately.

THE COLOR OF LIGHT

You might not always notice—because your brain does such a great job—but the color quality of light is always changing. The color of light when it's cloudy is different from when the sun is shining; the color of light in the early evening is different from noon, and so on.

Every type of light has a color-temperature value, which is expressed in Kelvin. As a standard, noon sunlight is 5500 Kelvin, or 5500 K. A higher color-temperature value results in bluer or cooler light. A value that is lower means the light is more orange, or warmer.

Mixed Lighting

Automatic white-balance and manual settings can never completely accommodate scenes that contain a mixture of light sources—commonly fluorescent and tungsten. You will have to make a decision based on the content of the image, then pick which area is more important to you.

A DSLR can be used in automatic white-balance (AWB) mode most of the time to deliver good results. The six photos show the same scene photographed in AWB and in five preset white-balance settings.

Automatic white-balance (AWB)

Cloudy

Cool white fluorescent

To be honest, there is no need to get too technical about color temperature, because your camera will deal with it for you. It's just a good idea to understand how it works.

If you look at a digital camera's white-balance menu, you will see several options. Most of the time, automatic white-balance (AWB) is the best setting to use. In this mode the camera automatically analyzes the quality of the light to deliver neutral-looking results.

AUTOMATIC CAN BE GOOD

The majority of AWB systems work well in a wide variety of lighting conditions, but they are not infallible. Obviously, the camera will do its best to deliver accurate results, but occasionally you may find that you have to use one of the presets.

Moving from outdoor to interior lighting is one example of AWB's inability to cope; you will probably get results that have an orange color cast. However, you can avoid camera error by using the appropriate preset. For artificially lit interiors, try the incandescent or fluorescent setting to avoid any color cast.

Some cameras let you fine-tune the presets. It is a nice function to have, but it's not always practical. Another option is to use custom white-balance, which lets you program the white-balance setting for the prevailing lighting conditions. An easy option is to photograph a sheet of white paper, and the camera will set and memorize

 RAW ADVANTAGE

If you're shooting exclusively in Raw, you can simply leave the camera set to automatic in all situations. You can adjust the balance later once you have transferred the files to your computer. Since the Raw file records everything the sensor records, there is no loss of quality.

a color-balance value that ensures that the paper will come out white. Alternatively, there are accessories that can accommodate a custom value. Shooting with this setting will result in neutral results.

Shade

Sunny

Incandescent/Tungsten

Inside your DSLR camera

Every DSLR camera is packed with features. Of course, there are the headline functions, such as autofocus, autoexposure, and white-balance systems. But if you scratch below the surface of a typical DSLR, you'll find all sorts of fantastic features. While many of these features and custom functions will be used only occasionally, it is good to know that they are available.

This sequence of six images was taken with the camera's continuous shooting mode. The movement of the helicopters rotors is visible.

DRIVE SPEED

In most cases you will want to take only one picture at a time, so the "S," or single-frame drive, mode is the best to use. However, there will be occasions when you will want to shoot a consecutive sequence of several shots. You can do this in the continuous shooting, or "C," mode, although shooting speeds vary from model to model. Most cameras allow up to three shots or frames per second (fps), while more advanced models may permit five frames per second or more.

The number of continuous shots you can take in one burst is limited by how fast the information can be transferred to the memory card. This takes longer than pressing the shutter. To compensate, cameras have a memory buffer that holds the images while they're transferred to the card. The larger the memory buffer, the more images that can be taken before the camera needs to stop and wait.

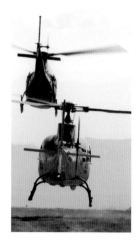
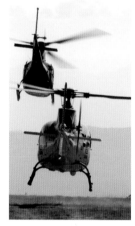
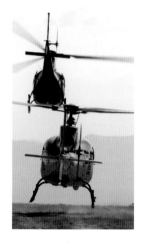

SELF-TIMER

This device allows a timed delay between the moment you press the shutter release and when the picture is actually taken. Some DSLRs give the option of either a short (2 seconds) or longer (10 seconds) delay. This is handy when you want to be in the picture yourself, and even more useful for hands-free photography.

WHITE-BALANCE BRACKETING

Mixed lighting can bring uncertain results. However, bracketing the white balance is an option—particularly with JPEG shooting. This is not as important when shooting in Raw format, because of its post-production versatility.

MIRROR LOCK-UP

The DSLR's reflex mirror flips up at the beginning of an exposure. This generates a vibration that can result in blurred photographs during long exposures. The mirror lock-up feature allows you to put the mirror up to prevent this, at the expense of a viewfinder image.

FLASH EXPOSURE COMPENSATION

This feature works like normal exposure compensation, but it can increase or decrease the flash output. It is a useful way to control the camera's fill-in flash mode. The default setting may use too much flash, so -1/3 or -2/3 will give better results.

Face detection

This technology detects human faces in pictures and sets the camera's focus and exposure systems up accordingly to get them sharp and correctly exposed. It is a feature that is usually seen on digital compact cameras, but it is now appearing on DSLRs. The Panasonic Lumix L10 can recognize up to 15 human faces.

This picture takes advantage of the mirror lock-up to ensure the maximum possible stability on a tripod when shooting.

 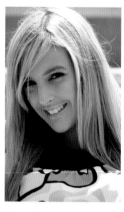 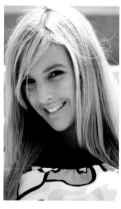 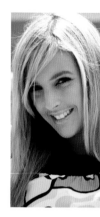

| Faithful | Landscape | Mono | Neutral | Portrait | Standard |

PICTURE STYLE

You might prefer more saturated pictures than the camera's default setting allows, or you may decide to shoot the scene in monochrome. Picture-style modes give you these options and many more. Some models will offer landscape or portrait styles, where the parameters to suit that particular subject have been decided by the manufacturer.

Advanced cameras offer the option to tailor your own parameters and to save them as user settings so you can recall them anytime.

LONG-EXPOSURE NOISE REDUCTION

If you shoot long exposures, images can suffer from too much digital noise. Setting the long-exposure noise-reduction mode helps to minimize this problem. However, the camera is unusable for the same length of time as the actual exposure while the image is being processed.

REAR OR FIRST-CURTAIN FLASH SYNC

The flash sync mode you set is only relevant with moving subjects. If you shoot a moving subject with first-curtain flash synchronization, it will appear to be moving backward. Set rear-curtain flash sync and the subject will appear to be moving forward.

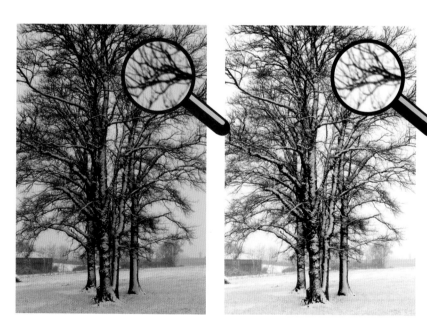

These photos were taken with the camera's picture-style modes. These cannot be undone on the computer.

These two pictures demonstrate the advantage of digital noise reduction, which was set for the photo on the right, but not the left.

EXPOSURE COMPENSATION

This function lets you quickly and precisely vary the exposure from the camera's meter reading. It usually works in ⅓-stop steps, up to ± 3 or 4 stops. If you use compensation, remember to reset it to its original position before taking the next shot.

AUTOEXPOSURE BRACKETING CONTROL

Exposure bracketing is the process of taking extra shots at different meter readings to ensure one perfect exposure. Bracketing is necessary only when the lighting is particularly extreme and you are unsure of getting the correct exposure. A bracketing control will let you shoot a number of frames at predetermined under- and over-exposure settings.

LIVE VIEW

Still in its infancy, Live View is already becoming a big hit with photographers. It enables DSLR users to compose their pictures using the LCD screen instead of using the optical viewfinder —just like a digital compact camera. Some models have a swivel screen, which makes it much easier to take pictures when holding the camera at a lower or higher viewpoint.

Technically, providing Live View on a DSLR is a remarkable feat. The viewing image in a DSLR is provided by a reflex mirror mechanism. Live View is possible by flipping the reflex mirror up so light can strike the

sensor. Depending on the model, you may get autofocus, but its efficiency might be restricted, or you might just have to rely on manual focusing.

This photo was captured using the Live View mode, which made it easier to hold the camera on the dog's level.

©Paul Walker

Sensor cleaning

Dust and hair settling on the camera sensor will appear as blemishes on your pictures—especially in areas of light, even tones, such as a blue sky or skin tones. These will need to be cloned out with the help of your image-editing software.

Olympus was the first camera maker to offer an integrated solution, the Supersonic Wave Filter (SSWF). It sits in front of the image sensor, and when the camera is switched on, the SSWF vibrates very rapidly to shake off any debris, which is then collected in a trough. The system works well. Other camera makers have developed their own sensor cleaning systems.

Improving Your
Camera Technique

Shooting sharp pictures

Autofocusing, advanced optics, and antishake camera systems have greatly reduced the chance of blurred photographs. Despite all this advanced technology, however, pictures of once-in-a-lifetime moments are ruined because of poor camera techniques. How you hold the camera, your stance, the way you press the shutter release, even the way you breathe can all cause blurred pictures.

HOLD THE CAMERA CORRECTLY

The first technique to master is holding the camera correctly, because the correct grip and stance can provide the most stable platform for taking pictures.

Modern cameras are ergonomically designed to promote good handling. A good example is the contoured handgrip, which allows a secure hold and the right forefinger to rest almost naturally on the shutter release.

The grip's design encourages the right hand to hold the camera body correctly, but the left hand is equally important when it comes to taking sharp pictures. Whether the camera is held horizontally or vertically, the left hand needs to be under the lens to provide maximum support.

You might think there is nothing tricky about pressing the shutter release, but less-experienced photographers can stab the release, shaking the whole camera at the very point of taking the picture. Learn to gently squeeze the shutter release, holding your breath at the same time to ensure the minimum amount of movement.

CHECK YOUR SHUTTER SPEED

Always be sure to closely monitor your shutter speed. The slower the shutter speed, the greater the risk of a shaky shot. The shutter speed is open for longer, which means you might move or shake during the exposure, or the subject might move.

As a rough guide, the shutter speed the camera uses needs to match the focal length of the lens you use. So if you are handholding a 70–200-mm lens at the 200-mm setting, be sure to use a minimum of 1/200 sec. If you change the zoom to the 70-mm setting, you need at least 1/70 sec.

These figures are practical minimums, and you are generally advised to use higher speeds when possible. How slow you can go depends on the photographer and the situation, although there are no absolute rules. For

USING A TRIPOD

A tripod will help you achieve optimum sharpness from your lenses if it is correctly used.

Always set up the tripod on solid ground, and splay its legs as wide as possible for maximum stability. Use a remote release or the camera's self-timer when taking pictures at longer shutter speeds. Also be sure to extend the legs first to get the necessary height, rather than relying solely on the central column.

Holding the camera correctly is an important technique to learn to shoot sharp pictures.

example, if it's a very windy day, you will need higher speeds than usual to avoid blurred pictures. Conversely, if it is a relaxing, calm day and you are shooting with a wide-angle lens, then sharp, handheld pictures at speeds as low as $1/4$ sec are definitely possible. However, always remember to double-check your focus before taking the picture.

A tripod is essential with long exposures. The low lighting levels and a small lens aperture for maximum depth of field meant that this twilight scene needed an exposure of six seconds at *f*22.

📷 MULTIPLE SHOTS

If you are shooting with a shutter speed at the lowest end of your comfortable range, it is usually worth taking a few frames, then comparing them and keeping the one that is the least blurred.

Setting better exposures

Digital SLRs have sophisticated metering systems to measure the amount of light falling on the subject and to deliver the correct exposure. Even a modest entry-level DSLR will have several exposure modes, as well as a variety of ways to measure light all designed to result in perfectly exposed photographs in every situation. Most of the time it all works well, but occasionally things can go wrong.

WHAT A METER DOES

Every scene is comprised of a range of tones. The width of the range depends on the scene, but a typical sunlit scene will have everything from deep blacks in dark shadow areas to bright white highlights. The wider the range, the greater the scene's contrast.

The camera meter looks at a scene and selects an exposure that will best reflect the shades it sees so they are not all shadow or highlight. An imaging sensor can only cope with a limited contrast range, and by setting an exposure that is between the deepest black and the purest white, the camera sensor is able to record the more interesting parts of that picture, which are not the brightest or darkest.

This works most of the time, but there will be occasions, particularly in bright light, when you have to make a choice. For example, in a strongly lit landscape, the sky is very bright and the foreground is very dark. The contrast between the two is too much for the sensor to manage.

Taking a meter reading from the sky will result in a very dark foreground. And exposing for the foreground means that the sky will lose all of its color and look almost completely blank.

TOOLS TO GET IT RIGHT

Every camera has features to deal with poor exposures. Generally, the most useful and the quickest are the Automatic Exposure Lock (AEL) and the exposure compensation feature.

In the previously discussed landscape photo, aiming the camera down so that the viewfinder image is dominated by the foreground and pressing the AEL button will record the meter reading. Now you can recompose and take the picture knowing that the foreground will show more detail.

The AEL is a very quick way to be sure that the camera exposes the area you want. Some cameras have the AEL linked to the shutter release, so partially depressing it also locks the exposure.

A histogram is a graphic representation of the tonal values within an image; the one shown below represents the picture on the opposite page.

On the left side, starting from pure black, are the darker tones. And on the right are the lighter ones, ending in white. The histogram for a typical daylit image will have a peak in the middle, and it will taper off at both extremes.

Because the histogram is an accurate indication of tonal values, it is a much better indicator of the quality of your exposures than the actual image on the camera's monitor.

If you see that the tones are bunched toward the left, or dark, side of the histogram, the image could be underexposed. If the histogram has its peak on the right side, it could be overexposed. If you see these extremes on the histogram, adjusting the exposure settings and reshooting is a good option.

The exposure compensation feature is nearly as quick, and it allows very precise control over how much or how little exposure you provide. It does require some experience to get the best out of it.

This feature's default position is 0. In situations when the picture comes out too dark, extra exposure is needed and the plus settings are used. The setting of +1 gives what is called an extra stop, because the adjustment is equivalent to widening the aperture by 1 stop. If your shot looks too light, a minus setting is needed, and this works in the same aperture stop increments.

How much is required depends on the scene and how well the camera copes in the first place. With the instant feedback of digital technology, you can immediately see the results of your adjustments. And if it is not right, trying again costs nothing but time.

This picture was exposed at f13 to retain sharpness in the foreground and background at $^1/_{60}$ sec and ISO 100. This was $^2/_3$ of a stop beneath the camera's automatic exposure value, which was too bright. A tripod was used for stability.

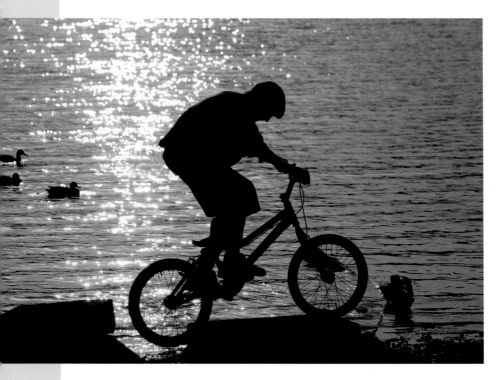

It would be wonderful if camera meters got every exposure correct, regardless of the lighting conditions. However, they can be fooled, especially in situations where the light is very photogenic. So it helps to know what to do when these situations arise.

INTO THE LIGHT

Shooting toward the sun, or light source, provides dramatic pictures, but you will need to get the exposure correct if you want pictures that will make you proud.

Backlit scenes are extremely contrasty, from deep black to pure whites, so it will help if you have an idea of the effect you want.

If you aim most camera meters toward a bright light, it will be fooled into thinking there is lots of light, and it will give a relatively short exposure. The almost inevitable result will be underexposure to the shadow details, resulting in a silhouette of the subject.

However, if you want more detail in the shadows, you have to take remedial action, although this will possibly result in losing the highlight details. It is difficult to be specific with exposure advice because every situation is different, and better exposures are possible through a variety of methods.

For example, you could set +1 or +2 on the exposure compensation control; use a spot meter to take a reading from the shadow details;

Above: Aim a camera lens toward a light source, and most camera exposure meters will automatically silhouette the foreground subject. The best silhouette pictures feature bold subjects that are readily identifiable.

Below: A dark interior with patches of bright outdoor light is a challenge for any exposure meter. If there is too little exposure, the highlights will look fine, but the interior will be too dark; too much exposure and highlights will be bleached out.

📷 EXPOSURE BRACKETING

In difficult lighting situations, you can secure a correct exposure by bracketing exposures. This requires shooting extra pictures below and above the camera's exposure reading. In theory, one shot should be accurate. Most cameras feature Automatic Exposure Bracketing (AEB).

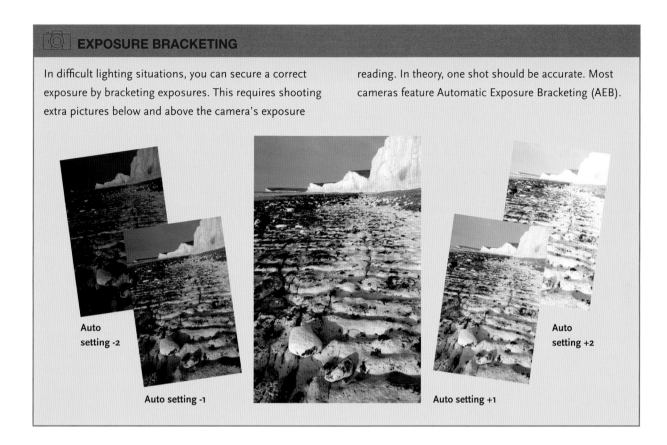

Auto setting -2

Auto setting -1

Auto setting +1

Auto setting +2

or zoom in with the lens, memorize the exposure reading with the autoexposure lock, and then zoom out and recompose the picture. Or you could bracket exposures to ensure that you get one perfect shot.

PREDOMINANTLY LIGHT OR DARK SUBJECTS

Try an experiment: Stand a person against a white wall and take a picture with the camera set to automatic exposure mode, then do the same against a black door. Afterward look at the results: Odds are you will have exposure failure in both pictures.

In the case of the white wall, the result will be influenced by the white that predominantly fills the frame; the camera sets an exposure aimed at revealing detail within that white area. Because the subject is generally darker than the white area, its tones will be at the darker end of the image. The result is an underexposed subject.

The opposite happens with the black door, which fools the meter into thinking there is less light. It will provide extra exposure and make your subject look pale.

This problem is easily corrected using the exposure compensation feature. For the white door, set +1 stop extra exposure, and for the black door, set -1 less exposure.

The way in which meters deal with these tonal extremes is why snow and beach scenes commonly cause problems. In both cases, dialing in some extra exposure using the exposure compensation feature will ensure white snow and golden sand. So be sure to set +1, or even +2, in very bright light if you want the scene to look real.

The art of focusing

Shooting sharp pictures is easy, thanks to autofocusing technology. At a touch of the shutter release, a typical DSLR will move into sharp focus more quickly than it is possible to manage manually—and it can do this in a wide variety of lighting levels. Taking a sharp picture is obviously important, but there are artistic considerations, too. So it is worth learning the importance of creative focusing and aperture control.

These two images of an allium were taken at the same time, but at different focusing distances. The image with the sharp allium head is the traditional approach. However, defocusing produces an interesting abstract alternative image.

TAKE CONTROL OF FOCUSING

The camera cannot think for you, so when you are focusing, pause for a moment and consider what you want to show in your picture.

You may want a shot that is sharp from near the camera to the far distance—a long depth of field. Or you may want your subject to stand out from a distracting background—a short depth of field. By thinking about where the camera is focused and your aperture choice, you can guarantee your desired results.

The aperture, or *f*-stop, that you use determines the depth of field in your picture. You can check this by using the viewfinder. During normal use, you will see a very bright viewing image, which helps with composition and focusing. But this does not give you an idea of how much depth of field is available and which areas will come out sharp.

For this reason, cameras are equipped with a depth-of-field preview button, which closes the lens aperture to the set value.

The viewfinder gets darker, so allow a short while for your eye to get used to the dimmer image. You will then be able to see how much more of the scene will be sharp in the final shot. If you want more of the scene to be sharp, or to circumvent focusing inaccuracies, set an even smaller aperture (perhaps *f*16 instead of *f*8).

In preview mode, you will also be able to see how the background interacts with the subject. If you find that the division between the subject and background are not distinct, try using a shallow depth of field—a lower *f* number. The wide aperture will throw the background behind the point of focus into an aesthetically pleasing blur. The flip side is that you will have a narrow zone of sharpness, so your focusing needs to be very precise.

Factors affecting depth of field

Depth of field is the amount of front-to-back sharpness within a scene. It is affected by a number of factors, including:

Aperture choice. The smaller the aperture (*f*11, *f*16, *f*22), the more extensive the depth of field. The wider the aperture (*f*2.8, *f*4, *f*5.6), the more shallow the depth of field.

Lens to subject distance. The closer you get to the subject, the shallower the depth of field becomes. Therefore, aperture choice and focusing becomes even more critical with macrophotography. With subjects that are distant, there is plenty of depth of field, even at modest apertures.

Focal length. Wide-angle and telephoto lenses have an identical depth of field if the image magnification is the same in the viewfinder. However, few photographers would use a wide-angle lens close to a portrait sitter to have the same frame-filling effect as a telephoto. This is because facial features become distorted and the effect is not very flattering. So in normal use, wide-angle lenses do result in greater depth of field than telephotos.

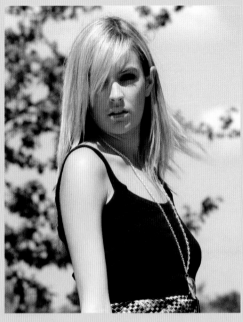

Taken at *f*16

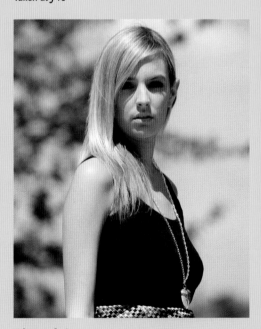

Taken at *f*5.6

The power of color

The world is a colorful place, and how you use color in your pictures says a great deal about you as a photographer. We all have our own tastes; some photographers like rich, intensely saturated colors, while others prefer a subtle style with soft pastel-like shades.

Understanding how colors can work together will help you take pictures with maximum impact.

A WORLD OF COLOR

It is easy to take color for granted and just snap away without thinking about how it can be used for great pictures. However, the relationship between hues and their arrangement in the frame can make a big difference.

How colors appear in print is mostly influenced by the prevailing light. In bright sunlight, colors can be rather strong, and the inherent high contrast means subtle nuances can be lost. The same subject in a more diffused light will appear to be a very different color: more intense and perhaps more delicate at the same time.

This is easy to prove for yourself. Take a picture of a colorful flower head in bright light, then repeat the shot with a sheet of card stock held up to shade the flower head in the shade. You will see a big difference.

Similar colors in a shot can result in harmonious images. The leaves on this tree are a similar hue, and the flat lighting has revealed the subtle differences. There was no need for a filter or white-balance adjustment.

Keeping
compositions
very simple and
dominated by
a single vibrant
color can have
extra impact.

Using picture styles

Most DSLRs allow you to fine-tune the color reproduction with picture-style modes. These make it possible to choose a style of color reproduction to suit the specific subject. Popular options are landscape, portrait, and monochrome. You may even choose your own parameters and store them as a user setting.

CALM COLORS ARE GOOD

Bright, vibrant color is not essential to every picture. A multitude of hues is not necessary, either. In fact, there is a great deal to be said for keeping it simple.

Scenes of monochromatic color or similar hues can work really well to evoke a calm mood. Or you can induce a different reaction by using strong colors that clash. A red traffic sign shot against a rich blue sky can have a very vibrant effect.

Pictures with a warm hue tend to be more welcoming and friendly than those with a cool, blue hue. An image's warmth can be enhanced when you are shooting by using a warm-up filter on the lens.

The overall blueness of this landscape has a very cool feel. It was taken early on a gray misty morning. The blue color cast was added by using the white-balance control at the incandescent setting.

Compose yourself

Imagine that your viewfinder is the photographic equivalent of an artist's canvas. How you use your canvas determines the success of your photographs; therefore, choosing the composition is key. But that's just the starting point. In the world of photography, rules are made to be broken. Some of the best shots are those taken from an entirely new viewpoint.

THINK OUTSIDE THE BOX

There are some rules of composition that are made to be broken. Consider them to be guidelines rather than rules, and use them where you feel they will improve the photograph instead of slavishly adhering to them.

The most common error made by less experienced camera users is to shoot in a horizontal format and to place their main subject centrally in the viewfinder. It is the most natural thing to do, but it is often the least effective pictorially.

It is much better to place the main subject slightly to one side or turn the camera on its side for an upright composition.

VARY YOUR CAMERA POSITION

Changing the camera viewpoint is such a simple technique but the difference it can make can be dramatic. In other words, your feet are an important composition tool.

Taking a step to one side, moving forward, or looking up or down can breathe new life into an ordinary subject and may create a cleaner background or provide a better view of the subject.

Another factor to consider is camera height. Most photographs are taken from standing height. Therefore, it's easy to get a different viewpoint— even on a common subject—just by kneeling or lying down. So long as it is safe, consider the other direction, too; you can climb a wall and get a completely different view of the world.

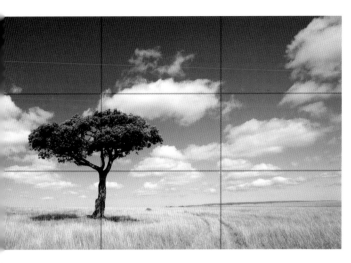

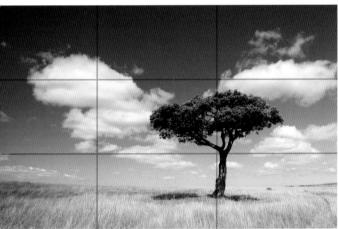

THE RULE OF THIRDS

The composition technique that tends to pull the viewer in is the rule of thirds. It is simple to understand and implement, and it is very effective for a wide range of subjects, such as the tree above.

Imagine that the viewfinder screen is divided into thirds and a grid is superimposed across and down the image. Next, simply position the focal point of your picture at one of the four intersections or across one of the four lines. The focal point could be a tree, the horizon, or a person, but positioning it using this rule will immediately improve the image than if the focus was placed in the middle.

REMEMBER YOUR FOREGROUND

The view offered by wide-angle lenses can result in weak pictures if there is poor use of foreground detail.

Landscapes, in particular, can look disappointing if there is no foreground. So it is always worth looking for a detail that can give the rest of the scene something substantial to attract the eye. A small lens aperture will ensure plenty of sharp detail to create strong lines that will lead the viewer into the scene.

FRAMES

Frames, whether natural or man-made, are great devices for making compositions stronger. A pathway, arch, doorway, overhanging branches, or even foreground flora can be utilized as frames to lead the viewer into the picture. Using a frame will help you deal with boring, bland skies and add detail and interest to your shot.

As compositional aids, frames can be in sharp focus or very out of focus. They do not work as well when they are in-between, because it looks unintentional, so be sure to check your depth of field.

LEAD-IN LINES

A lead-in line can be a road, wall, fence, or row of trees that is used to attract a viewer into the picture. These lines are easily found when you're looking at a landscape, but they also work in portraits, action pictures, and townscapes.

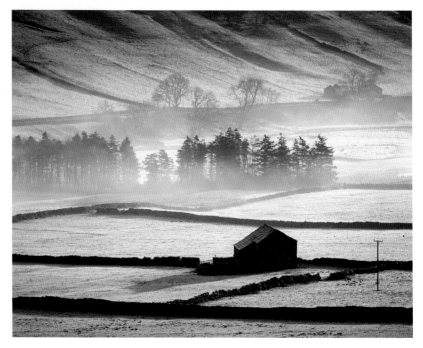

WATCH THE BACKGROUND

Before pressing the shutter release, pause for a moment and look at the edges of the viewfinder image and behind your subject. This final check might reveal a tree growing out of a subject's head or a road sign in the foreground that could spoil your otherwise pristine landscape. Remember to check your aperture choice, because it has a profound impact on the background and how it interacts with the subject.

BREAK THE RULES

Composing a landscape with the horizon running through the center of the frame rarely works, but in the right situation it can deliver great results. The same applies to all of the rules of composition. By all means, use the rules as a guide, but always be prepared to try something different.

Using a flash

A flash allows you to take pictures in complete darkness, so it is an incredibly useful accessory. Fortunately, most DSLR cameras have a built-in flash so photography is possible at any time. However, internal flashes are relatively low-powered. Furthermore, the exposure is usually determined by a through-the-lens metering system, so you can usually take a simple point-and-shoot approach.

A separate flashgun offers more power and flexibility than the camera's integral built-in device.

A FLASH IN THE PAN

The main attraction of a DSLR's built-in flash is its convenience. It is always there to bring light to dark situations, but it does not give great modeling, and because of its close proximity to the lens axis, there is a greater risk of red-eye.

If you wish to be more serious about flash photography, consider buying a separate flashgun that sits in the camera's hotshoe. You gain better modeling, more power, and greater flexibility.

However, the built-in flash does have some creative use. Most people switch on their flash only when the light is low, but it is really useful to fill in shadows when the sun is shining brightly.

Taking portraits in sunlight can bring high-contrast results with blocked-up shadows. Turning on the flash and selecting the fill-in flash mode

In this picture a relatively slow shutter speed causes the motion-blur which can be seen in the light trails, but the girl is only lit by the momentary flash so doesn't appear blurred.

will lighten the deep shadows and add highlights to eyes. The trick with a fill-in flash is to provide enough to lighten the shadows, but not so much that the flash becomes obvious. If the amount of fill-in is incorrect, use the flash exposure compensation control to adjust the flash output.

TRY SOMETHING DIFFERENT

Things can be more creative and unpredictable with the slow-sync flash mode. This is fun to use on moving subjects—or you can move the camera with a still subject.

Slow-sync mode mixes a relatively long daylight exposure with the very brief, action-stopping duration of a burst of flash. A typical slow-sync flash picture is an attractive combination of blur and sharpness.

Slow-sync shooting is usually possible with two modes that control how the flash synchronizes with the shutter. The options are first-curtain or rear-curtain synchronization. Shooting with first-curtain flash sync will make a subject appear to be moving backward. With rear-curtain, or second-curtain, the subject's movement will look correct.

A fill-in flash lightens deep shadows when the daylight is very contrasty. Getting the right amount of flash to have a natural effect takes a bit of practice.

Set the right speed for flash

Camera manufacturers have gone to great lengths to be sure that the correct shutter speed is automatically set for flash photography. However, if your shutter speed is too fast you will find that the picture will be totally or partially black.

FLASH MODES EXPLAINED

Most built-in flashes have a variety of operating modes:

Auto detects when light levels are low, then automatically fires.

Red-eye reduction minimizes the effect where eyes can look red. The flash will pulse several times very quickly to encourage the eye's iris to grow smaller, prior to the flash firing.

Fill-in fires the flash in daylight to lighten dense shadows. Its output can be controlled with a flash compensation feature.

Slow-sync fires the flash in conjunction with a slow shutter speed. Use this to produce pictures that combine blur with the movement-freezing qualities of flash. Slow-sync mode can work in either first-curtain or second-curtain (also known as or rear-curtain) flash synchronization. With second-curtain sync, moving subjects will appear to move forward.

Using
Lenses and Filters

4

Zooming along

A camera body is precisely engineered and packed with an amazing amount of computing power and high technology. However, it is ultimately nothing more than a very sophisticated lightproof box. Inside this box is the imaging sensor, the shutter mechanism, and the playback system. But outside, on the front, is the crucial lens through which all the light must pass first.

A lens with a wide focal-length range, such as a 28–300-mm superzoom, will cope with most subjects. These two pictures were taken from the same spot at the two extremes of a superzoom.

TWO ZOOM TYPES

Modern zoom lenses are capable of providing high image quality. A prime lens of the same focal length will provide superior quality prints, although this might be apparent only on an optical test bench. In practice, modern zoom lenses will offer attractive enlargements as long as you are using proper camera techniques.

There are two zoom lens designs, and they have different characteristics. The one-touch zoom has the zoom adjustment and focusing functions in one push-pull barrel. The more common, two-touch zoom has both of these functions on individual barrels.

The handling differences between the two designs are relatively minor. The one-touch zoom can be slightly awkward, because as the lens is zoomed in or out, the focus can shift very slightly. And this is enough to result in a blurred image. The two-touch operation means that once the subject is in sharp focus, you can take your time zooming in and out to get the perfect composition.

GETTING THE BEST

All lenses have an optimum aperture at which they give their best results in terms of contrast, resolution, and sharpness. Generally, this is two or three f-stops below their maximum aperture. So if you are using an $f4$ lens, the best aperture to shoot at is $f8$ or $f11$.

Regardless of aperture choice, it is important to make sure that your focus is accurate. It is very easy to rely on the camera's autofocusing system, but it is worth remembering that no autofocus system is infallible. Be sure to closely inspect the viewfinder image or use any focusing confirmation signal that might be present. Another option is to zoom into the scene, check your focus, and then recompose.

A final word about zoom lenses: Less experienced photographers rely more on the extremes and forget about the settings in the middle. Learn to take it slowly when it comes to zooming in and out, and look for the perfect composition.

28 mm

300 mm

Creative zooming

Operating the zoom control during a long exposure can produce eye-catching effects, especially with bright, colorful subjects, and it is easy to do.

The camera needs to be held firmly in position, so you will need a tripod. Setting a small lens aperture of $f16$ or $f22$ and a low ISO sensitivity will give you a suitably slow shutter speed. You need enough time to start the exposure and operate the zoom barrel, so allow for at least one second longer.

Press the shutter release and, about halfway through, operate the zoom barrel in a smooth motion—without moving or jarring the camera. Zooming in provides different results when compared to zooming out, so it's worth trying both to see which look you prefer.

Prime time

Despite the prevalence of zooms, many experienced photographers still use fixed focal-length lenses, or prime lenses. Prime lenses are restricted to one focal length, but they have many advantages over zoom lenses, in both technical and quality aspects.

LENS DISTORTION

Most camera lenses suffer from distortion, although it is usually tightly controlled and not evident in day-to-day use.

Pincushion distortion causes the straight lines at the edges of the picture frame to bow inward, producing a pincushion shape. Telephoto lenses are more likely to suffer from this effect.

Barrel distortion causes straight

lines to bow outward, forming a barrel shape. This distortion is more likely to happen when using wide-angle lenses.

Zoom lenses that cover a very wide focal-length range can suffer from both distortion types at either end of their range.

A prime 500-mm telephoto lens was used for this shot of a lion drinking from a waterhole in Kenya's Masai Mara game reserve.

PRIME ADVANTAGE

A prime lens has wider maximum apertures when compared to a zoom lens set to the same focal length. A prime 28-mm lens may have a maximum aperture of ƒ2, while a zoom lens that can be adjusted to the same focal length is more likely to have a maximum aperture of ƒ4—two stops slower.

Faster lenses also produce a brighter viewfinder image, which makes focusing and composing easier. If you are taking advantage of the wider aperture, you can sharpen your pictures with a faster shutter speed, or reduce noise with a lower ISO for the best possible image quality.

Practical advantages aside, prime lenses also force you to think about composition. For example, if you want a closer view, you do not have the option of zooming in. Instead, you have to physically move closer to get the desired frame. This obviously slows you down, but it may encourage more thought before pressing the shutter release. Working harder at composition will also help improve your photography skills.

Teleconverters

Optical accessories called teleconverters can expand your lens collection at a relatively low cost. They fit between the camera body and the lens, and they are available in a variety of magnification strengths: 1.4×, 1.7×, and 2×.

The quoted figure indicates how much the focal length of the attached lens is increased. Therefore, a 100-mm focal-length lens fitted with a 1.4× converter becomes 140 mm or 200 mm with a 2× model.

On the surface, teleconverters look like an attractive option, but there are downsides. They are optical accessories, so there is a negative impact on the image quality, and they often need to be used at small apertures to minimize this effect.

They also result in light loss: One stop is lost in the case of a 1.4× model, and two stops are missing with 2× converters. A 100 mm ƒ2.8 becomes a 140 mm ƒ4 with a 1.4× converter, and with a 2× converter it becomes a 200 mm ƒ5.6. This is a double assault on your light options, which will lead to faster ISO settings and accompanying noise.

Shot with a 200-mm lens on its own.

Shot at 200 mm with a 2× teleconverter.

Open wide

Compared to a standard lens, wide-angle lenses have a wider field of view and they include more of the scene in the photograph. This makes them ideally suited to photography in cramped conditions or when you cannot stand back far enough to fit in all of the scene.

Wide-angle lenses range from specialized fish-eye optics that result in greatly distorted images to moderate wide-angles that have a view similar to one from the human eye.

BANISH EMPTY SPACES

Compositionally, wide-angle lenses need to be used with a little care to shoot exciting pictures. The advantage of adding more to your picture works only if you don't end up with an image dominated by empty expanses or blank sky.

Foreground interest is important when it comes to wide-angle photography; your best weapon to banish a dull foreground is your feet. Changing your camera position or viewpoint is especially powerful with wide-angle lenses. If the foreground lacks interest, taking a stride or two to one side can make an enormous difference. Kneeling down or climbing up a few steps will also create a different viewpoint.

Moving in closer is another option, if you think there is too much blank foreground. This will make you fill the frame with your subject and encourage you to think about how the elements within your composition will interact with each other.

📷 CROP FACTORS

Below are the crop factors for some well-known DSLR models.

35-mm 36 × 24-mm full frame
Canon EOS 1Ds Mk II/III, Nikon D3 (36x23.9 mm FX format)

1.3×
Canon EOS 1D MkI/II/III

1.5×
Nikon DX, Pentax, Samsung, Sony Alpha

1.6×
Canon "Digital Rebel" series, also known as EOS 350D/400D/ 30D/40D in Europe and Digital Kiss in Japan.

1.7×
Sigma SD10, SD14

2× Four-Thirds format
Olympus, Panasonic

This young girl was photographed at 20 mm, a relatively wide angle, which reveals a great deal of unnecessary background and is an unflattering portrait angle.

Use a lens hood

Stray light striking the front of the lens can cause flare or ghosting, but a lens hood can minimize these risks. A lens hood can also offer physical protection for the lens, too.

However, most lenses are zooms, and a hood that works at one end of the zoom range will be unsuitable for the other. It will either be too long or too short, and the corners of the image will be cut off.

The lens hood that came with your zoom lens will be a compromise, but it is better than nothing.

This picture has a wide aperture of *f*2.8 and therefore a short depth of field. This causes the background to be out of focus and the bird's face in the foreground to be the focal point of the picture.

COMPOSE YOURSELF

For an attractive composition, look for strong lines that will lead the viewer into the scene. Look for a fence, a meandering river, or a road stretching into the far distance, for example.

To get the maximum amount of scene in focus, set a small lens aperture to get everything sharp from a few feet (about a meter) in front of the camera to the far distance. You can also achieve more front-to-back sharpness by switching to manual focus and focusing slightly in front of your main subject. Remember: The full depth of field is approximately $\frac{1}{3}$ before and $\frac{2}{3}$ behind the focus point.

Because wide-angle lenses have more depth of field than telephoto lenses, they are more tolerant in terms of focusing accuracy. With ultrawide lenses such as 10 mm and 12 mm, the potential depth of field—even at modest apertures—is extensive.

Therefore, many experienced photographers, especially when taking candid pictures, sometimes switch to manual focus and set a focusing distance of 10 feet (3 m) and an aperture of f 11. This gives front-to-back sharpness from approximately 6 feet (2 m) to infinity, which means it is possible to shoot sharp pictures without needing to focus.

BUYER'S GUIDE

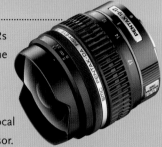

As discussed on pages 17 and 76, many DSLRs have imaging sensors that are smaller than the traditional 35-mm full-frame format on which focal-length measurements are based.

The pictorial effect you get with a particular focal length varies according to the size of the sensor.

In the table below, the lens's actual focal length is shown under the 35-mm format column. The subsequent columns list the effective focal length for DSLR cameras with other crop factors. Therefore, a 24-mm focal-length lens fitted on a DSLR with a crop factor of 1.6× has an effective focal length of 41 mm in the 35-mm format. It is worth repeating that a lens's focal length does not actually change. It is only an effective change caused by using a sensor smaller than the full-frame 35-mm format.

Crop factor

35 mm	1.3×	1.5×	1.6×	1.7×	2×
12 mm	15 mm	18 mm	19 mm	20 mm	24 mm
18 mm	23 mm	27 mm	29 mm	30 mm	36 mm
20 mm	26 mm	30 mm	32 mm	34 mm	40 mm
24 mm	31 mm	36 mm	38 mm	41 mm	48 mm
35 mm	45 mm	52 mm	56 mm	59 mm	70 mm
50 mm	65 mm	75 mm	80 mm	85 mm	100 mm
85 mm	110 mm	127 mm	135 mm	144 mm	170 mm
100 mm	130 mm	150 mm	160 mm	170 mm	200 mm
135 mm	175 mm	202 mm	216 mm	230 mm	270 mm
200 mm	260 mm	300 mm	320 mm	340 mm	400 mm
300 mm	390 mm	450 mm	480 mm	510 mm	600 mm

In this scene the foreground and background are in sharp focus because it was shot at a narrow aperture of f13. Even on a sunny day a relatively slow shutter speed of 1/60 sec at ISO 100 was needed because of the limited light through the narrow aperture.

This shot was taken in evening light, using a tripod, with an aperture of f6.3 and a shutter speed of 1 sec.

Pulling power

Telephoto lenses have a greater magnification than a standard lens, so the subject appears larger in the viewfinder. The longer the lens, the greater the magnification. Therefore, telephoto lenses are ideal for photographing distant subjects, such as wildlife and sports, without interfering with the action.

Monopod management

Good technique is essential with a monopod. Use your legs to form a tripod, with the monopod as the third leg. You will find it is possible to get sharp pictures at surprisingly long shutter speeds.

GET IT RIGHT

The greater magnification, or pulling power, of telephoto lenses generates its own problems, presenting some challenges to getting the best possible results. Therefore, perfecting your camera technique is very important.

Longer lenses are more prone to camera shake than shorter focal lengths, and it is easy to appreciate why. Telephotos magnify the subject, but they also enlarge any degree of movement the lens experiences, too. While shooting at a shutter speed of 1/60 sec using a wide-angle lens is a standard practice; doing this with a long lens is risky, and the likelihood of camera shake is high.

A stable tripod with a remote release to make exposures is your best bet for good results. Tripods are the ultimate camera support, but they are not especially convenient. They are relatively heavy and bulky, and they are slow to use. Tripods work well for landscape photography, but they can be restrictive when it comes to shooting action. In this case a monopod is the better option.

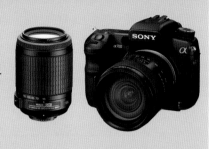

BUYER'S GUIDE

Antishake systems

More photographs are spoiled by camera shake than any other factor. So several camera manufacturers have developed shake-reduction systems to solve the problem.

Canon's Image Stabilization (IS) technology is one of the most popular systems. The engineering is very effective, but its downside is that it is lens-based and not part of every Canon lens. Nikon offers a built-in lens vibration reduction system under the tag VR.

Other manufacturers, including Panasonic, Pentax, Samsung, and Sony, have built-in systems, which means it is available regardless of the attached lens.

There is a number of variables, but generally an antishake system will have a gain of two stops, so you can shoot at 1/30 sec and receive results similar to 1/125 sec without needing stabilization.

The picture opposite was captured at a 132-mm focal length—near the high end of a 28–135-mm zoom. The other settings were f5.6 at 1/60 sec, ISO 100.

A telephoto lens captured this shot of the Sydney Harbour Bridge behind the Opera House from a considerable distance.

ONE-LEGGED FRIENDS

A monopod is basically one leg of a tripod that has a fitting to attach a camera or lens. While a tripod stops camera movement in all planes, a monopod stops it only vertically. So it is important to perfect your technique for standing when using one. Ideally, the monopod and your own two legs make a tripod of sorts—be sure to keep your feet apart to form a steady shooting platform.

Longer telephotos, which are heavier, have a special collar to fit a tripod or monopod. This can be rotated and locked in position to suit either vertical or horizontal-format photography. If you have a lens with a collar, use it because this is where the center of gravity is located. Using the camera's tripod mount would strain it. The tripod collar will also give you better balance and greater stability.

Accurate focus is crucial with any lens, but it is more important with telephotos because there is less room for error. Try and maintain an aperture of f 11 or more. Therefore, if you misjudge the focus, the picture will still be sharp.

With a telephoto lens focused on a subject a short distance away, setting the same aperture will give a shallow depth of field; the zone of sharpness might extend only a couple of inches (a few centimeters) beyond where the lens is focused. If you make a small error of judgment at this distance, the result will probably be unacceptable. Longer distances will increase the margin of error.

Captured at a 180-mm focal length (crop factor 1.7), only the light appears to separate the foreground and background, which seem closer to each other than in reality.

PUT IT IN PERSPECTIVE

While wide-angle lenses tend to add a feeling of spaciousness, telephoto optics can be used to compress perspective. You can check the effect by training a telephoto lens on a distant group of buildings. You will see that everything appears to be very close together.

Although the effect is more pronounced with longer lenses, even a modest telephoto lens will have a compression effect, which can be used effectively in compositions. Setting a small lens aperture will ensure good front-to-back sharpness. But it is possible to put the limited depth of field of telephotos to good use, too.

This flattened perspective effect is great for distant scenes, but with subjects much closer to the camera, a shallow depth of field will make them stand out boldly from the background.

Portraits are well matched for this technique. Messy backgrounds can make a picture look cluttered, but a long lens set to a wide aperture will throw anything behind the subject nicely out of focus.

This picture of an English cathedral behind a row of houses shows the flattening effect of a long focal length.

Get in close

Macro lenses are specially designed to focus much closer than normal lenses, so you can capture images of nearby objects. If you like close-up photography, you will need to invest in a macro lens to make the most of your small subjects.

CLOSER FOCUSING

Macro lenses have a focal length just like other lenses, and their effect is the same for identical focal lengths. In short, a 100-mm telephoto lens will provide the same coverage as a 100-mm macro lens. The difference is, the macro lens can focus much closer.

While a normal lens might focus as close as 3 feet (1 m), a macro lens could focus at 12 inches (30 cm). The ability to get so much closer allows you to achieve a greater magnification, and a small subject can appear larger in the picture.

Traditionally, a true macro lens has a life-size maximum magnification ratio, so the subject's image on the sensor appears the same as the actual subject. Many zoom lenses offer a close-focusing ability that doesn't go this far, but they still use the term macro.

Extra stability
Some DSLRs have a mirror lock-up feature, which is worth using if your camera has it. Be sure to compose, meter, and focus on the subject before engaging mirror lock-up. Once it is pressed, the camera's reflex mirror will flip up, blacking out the viewfinder. Wait a few seconds for the camera to settle before taking the exposure.

A moisture drop on a tulip head is captured at a _f_3.2 aperture, making even the nearby background out of focus.

FOCUS MANUALLY

Relying on the camera's autofocus is sometimes risky because the system might lock onto the wrong part of the subject or may be unable to focus because the composition lacks strong lines. Therefore, switching to manual focus is advised.

Another factor that affects image sharpness is depth of field. This zone of sharp focus gets narrower as you close in on a subject, which makes accurate focusing very important. Selecting a small lens aperture such as a/50 offsets the effect.

You will probably need a long shutter speed to compensate for the narrow aperture. However, it is a good idea to use a camera support to maintain a high-quality image. If you are composing a shot and the camera is on a tripod, use the camera's self timer or a remote release to maximize the stability.

Despite an aperture of ƒ11, at this close range the depth of field is very shallow.

Magnification ratios

The focusing barrels of macro lenses are marked with magnification ratios as well as actual focusing distances.

At a minimum focus, a typical macro lens has a maximum magnification ratio of 1:1, which means that the subject appears life-size on the sensor. A ratio of 1:2 equals a magnification ratio that is half life-size.

1:1 Life-size

1:2 Half life-size

1:4 One quarter life-size

Camera filters

The front of a camera lens has a screw thread that accepts filters and other accessories. Filters were essential with traditional cameras because they altered light before it reached the film, and qualities such as color and contrast could be modified.

Digital photography and image-editing software allow for an enormous amount of creative freedom, and camera filters are not as necessary. Nevertheless, filters remain tremendously useful; there are a few that are definitely worth having in your camera bag.

POLARIZER

If you buy only one filter, make sure it is a polarizer. Its unassuming gray appearance belies its immense usefulness for many forms of photography. It can control reflections off painted surfaces, glass, or water, as well as enrich weak blue skies and cut down glare, which helps saturate colors. And it is unique because its effect cannot be replicated in image-editing software.

The polarizer's effectiveness varies depending on the lighting conditions. But check this while looking through the viewfinder and rotating the filter in its mount or holder.

ULTRAVIOLET/SKYLIGHT FILTER

Ultraviolet and skylight filters are ideal for physically protecting the front of the lens. These filters are virtually colorless, and they do not have a dramatic effect on the scene. Skylight filters have a very faint pink tinge that removes any excess blueness.

WARM-UPS

Warm or orange-toned pictures appear more welcoming and friendly than those with a cool, blue look. For portraits, a weak warm-up filter can enhance a suntan or just add some color to a pallid complexion. Warm-ups are also used for landscape pictures.

The 81 series of filters is the most popular type of warm-up filter, with ratings from A to EF. 81A is the weakest, and 81EF is the strongest. In the 81 series the intervening stages are B, C, and D, but other filters are not always available in as many iterations. Many photographers use the less intense filters, such as an 81A or 81B. The 85 series can also be used.

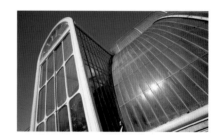

Without polarizer

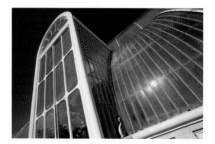

With polarizer

NEUTRAL DENSITY

Neutral density (ND) filters are gray and come in various strengths. They absorb light when there is too much to achieve a particular effect. For example, when shooting a waterfall, it may be too bright to allow a long shutter speed to blur the flowing water. A neutral density filter will cut down light levels and allow you to produce the blur—without affecting the color of the light.

A 2× neutral density filter absorbs one stop of light, and an 8× filter takes up three stops. In other words, if an unfiltered scene needs a shutter speed of 1/60 sec, it can instead be exposed at 1/30 sec with the 2× neutral density filter, or 1/8 sec with the 8× filter.

GRADUATES

Graduated filters are clear on one half and colored on the other, with a subtle transition in the middle. They are often used by scenic photographers when there is too much brightness or contrast in the sky. A graduate filter helps control that contrast. The most popular graduate is the gray or neutral density filter because each will darken the sky without adding any color. Other colors worth considering are blue (to add color to blank skies) and orange (to enhance sunsets).

SOFT FOCUS

Modern lenses can be too sharp, so using a soft-focus filter to add some gentle diffusion can be helpful. Portraits, in particular, often look better with a touch of soft focus.

Graduated

Warm-up

Neutral

Image shot without soft focus

Image shot with soft focus

Shooting to Suit
Your Subject

Landscapes

Landscapes are a very popular subject to shoot, probably because they are so accessible, yet so hard to master. It is relatively simple to take good landscape photographs. However, it is a real challenge to make them outstanding.

WORK THE LIGHT

As with most types of photography, the quality of light is a key factor. During the course of a day, the same scene changes from one hour to the next. Both the angle of the light striking the landscape and its color change during the day as the sun shifts position.

At dawn the low sun shines a light that is also very warm and orange. As the sun rises higher above the horizon, that intense warmth gives way to a gen tler coziness that gradually dissipates.

By noon the sun is at its highest point and its light can be very cool and blue. The light is also very harsh and unforgiving, and it lacks modeling. To be honest, this type of light is not optimal for photography.

As the day progresses the sun drops lower in the sky, and the more oblique angle reveals textures in the landscape that were missing a couple of hours earlier. The light also gets slightly warmer.

Of course, the light looks very warm at sunset and the landscape has an orange glow similar to the one at sunrise.

This shot shows the benefits of keeping an eye on the time as you shoot; the rich red rocks are clearly enhanced by the "golden hour" light.

Appreciating how the light changes from hour to hour and season to season, and the impact it has on the landscape are the first things an aspiring landscape photographer needs to understand. Naturally, the impact of the change from season to season depends on where you live. Leaves tumbling to the ground in the fall, or fresh growth in the spring are great subjects. So once you've chosen your subject, you can start to think about the lighting.

READ THE WEATHER

The real wonder of landscape photography is that the same scene can look different from hour to hour, day to day, and season to season. And that is before the unpredictability of ever-changing weather conditions is taken into account.

Many people love to use their cameras when it is warm and sunny, but the most dramatic conditions for spectacular landscape pictures can also be the most uncomfortable for photography. If you brave mist, frost, snow, or rainstorms, you will be rewarded with fantastic pictures.

Unusual weather conditions can transform everyday scenes. Therefore, sights that you normally take for granted can suddenly become worth some attention.

However, keep in mind that your digital SLR is a sensitive electronic device, and if rain gets into the mechanisms, it might stop working.

This is usually temporary, and the camera will be fine once it has dried out. If you do end up taking pictures in the rain, put the camera in a plastic bag with a hole cut out for the lens to poke out. This will give the camera some protection. A skylight or ultraviolet filter will keep water droplets off the front of the lens, but it will need to be dry for shooting.

USE SMALL APERTURES

If there is an interesting foreground, using a wide-angle lens and setting a small lens aperture, such as $f16$ or $f22$, will provide sharpness from 3 to 6 feet (1–2 m) in front of the camera position to infinity.

You can check out the effect of your aperture selection by using the camera's depth-of-field preview button. Pressing this when you have a small lens aperture will make the viewfinder image very dark. Allow some time for your eye to become accustomed to the darkness before making a judgment.

TONE DOWN THE SKY

A bright sky and a dark foreground present a contrast nightmare. But it is a situation faced by landscape photographers almost every time they go out with their cameras.

This dilemma can be resolved with image-editing software. However, there is an advantage in sorting it out when you shoot by using graduated filters. Plus you can preserve that sky and subject detail in the same shot.

Graduated filters come in many colors, but the most useful is gray. Grads, as they are often called, are colored in one half and clear in the other. They have a smooth transition in the middle.

In high-contrast situations you may need to use two filters in combination to get the effect you want. Be make sure they are spotless to minimize the risk of flare.

The sunlight coming from in front of the camera creates almost silhouetted areas that emerge from the haze.

FILTER FUN

Filters are great allies when it comes to photographing scenery. If you decide to buy just one filter, choose the polarizer because its effect is impossible to recreate in post production. It cuts down reflections, reduces glare from foliage and rock faces, helps slice through haze, and enriches blue skies. Also, because it absorbs light and is neutral gray, it can be used like a neutral density filter when you want to shoot using a longer shutter speed.

When shooting landscapes the polarizer is incredibly useful. However, using it takes some adjustment. You may find that it does not work consistently; it might intensify a blue sky one day, but not the next. This inconsistency is normal, and you are not doing anything wrong if it happens.

To darken a blue sky, a polarizing filter cuts down polarized light, and the amount of polarized light depends on the conditions. Generally, the part of the sky that is most affected by the polarizer is at right angles to the sun.

To figure out where the polarizer has the greatest effect on a sunny day, point at the sun with your forefinger and have your thumb cocked. Twist your wrist and the area of the sky where your thumb is now pointing to is where the polarizer will work best.

Shoot the sun

Few photographers can resist photographing spectacular sunrises and sunsets, but you must take care. Looking at the sun through an optical instrument like a camera can cause irreparable eye damage. If you are going to do it, only shoot when the sun is very low in the sky and diffused by thin cloud and haze, or hidden behind a solid object.

Technically, sunrises and sunsets can cause severe underexposure and the result will not have the subtlety that you may have desired. Rather than aim the camera directly at the sun, meter to one side from a patch of bright sky, and use the autoexposure lock to memorize the reading before recomposing the picture.

Color filters can enhance sun pictures, but generally, nature is pretty adept at providing vibrant colors.

People

Everyone loves photographing people. It might be family and friends on vacations or special occasions, or it could be interesting characters on the street. Catching magical moments with your camera is not difficult. And whether you like your pictures posed or naturally candid, improving your results can be easily achieved with just a little effort and some easy-to-remember techniques.

Side lighting will emphasize your subject's features. Do not use light from directly behind the camera.

FRAMING UP

Taking posed pictures is usually easy to do because everyone is aware of your camera and the situation. You will see pictures of this style in every family album.

However, shooting natural-looking pictures is a bigger challenge for your camera skills and, consequently, they may also be more rewarding.

Candid photo opportunities come and go with amazing speed, so you need to be prepared to catch those fleeting expressions in the first instance. Dithering with camera settings can mean your pictures lack any spontaneity. Instead, be sure to have the camera set up and ready to go with the right lens in place.

Make sure the camera is set to autofocus, automatic exposure, and an ISO sensitivity to suit the lighting. Program Auto Exposure (AE) mode is perfect for point-and-shoot photography, and because portraits are generally shot at wide apertures (low f numbers), an ISO speed of 200 or 400 will allow shutter speeds fast

Captured at ƒ4, this portrait has nice catchlights and a flattering 126-mm focal length.

Capturing children on film often requires a little patience and ingenuity, but a playful look can be very rewarding.

Filling in shadows

While a flash unit is most useful when there is little light, it is also helpful on the sunniest days.

Direct sunlight produces strong shadows that can look unpleasant, as well as unflattering to your subject. Heavy shadows can be lightened with a blip of light from the camera's flash, but it does take a little practice to use the right amount. Too much light and the effect can look unnatural; too little and the effect is barely noticeable.

enough for action-stopping shooting even in dull light.

Many cameras have an auto ISO function that will assess the lighting levels for each shot and set a suitable sensitivity. This is worth considering if your lighting conditions are frequently changing. Some of the latest DSLRs allow you to set a predetermined ISO range. This improves image quality because you can stop the camera from using the very high ISO settings where digital noise is an issue.

LOOK BEHIND

Once you are free of some technical constraints you can concentrate on the action in the viewfinder. When a situation is evolving quickly, it is easy to overlook distracting elements in the background, which can look awful in the final picture. The classic example of this is a tree or streetlight seemingly growing out of someone's head.

Before pressing the shutter release, a quick scan around the viewfinder can help avoid these basic errors. However, with an DSLR you also have the option of using a wide aperture. At ƒ4 the depth of field is much shallower, which means the subject you focus on will stand out more effectively from the background. A check with the camera's depth of field preview will confirm the effect.

However, using a wide aperture does mean that focus is critical. Be sure to double check that the subject's eyes are sharp before taking the picture. Just as people naturally look closely at eyes in real life, it's the first place you look in a picture. So it is important to be sure that all eyes are in sharp focus.

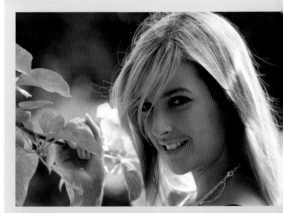

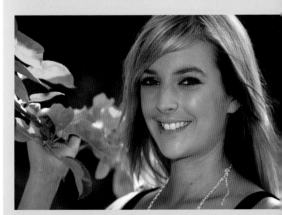

Give yourself a project

You probably have plenty of photos of family and friends, and you will probably take plenty more in coming years. But you could begin a portrait project, and take pictures that have a common pictorial theme. These are much more photographically challenging than snapshots.

My project, which is still on-going, was to photograph family and friends, and present the pictures in black-and-white in a square format. This originally started as a film project, but has migrated to digital capture. The concept remains the same.

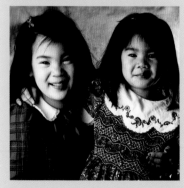

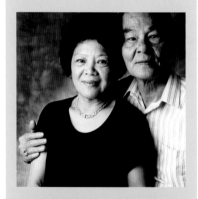

THE CANDID APPROACH

Taking natural-looking pictures of people you know is one thing. Trying this with complete strangers takes a different approach—mentally and practically.

You may not feel comfortable walking up to a stranger and asking if you can take a photograph. This direct approach demands confidence, but it often results in great pictures. The instant feedback of digital imaging also helps, because you can show your subject the images.

If you prefer to be more discreet, use a telephoto lens and shoot from a location where the subject is unaware of your presence. Or you can shoot from the hip, which is taking pictures when the camera is hanging around your neck or off your shoulder.

This candid photo of a group of buskers was shot from the hip at $f8$—an aperture small enough to allow some leeway in focusing.

Obviously, composition is a matter of guesswork, but this is part of the fun—so expect a high failure rate. At least with digital shooting, there is no wasted film.

Grabbing pictures successfully with this technique needs a lot of luck, but setting up the camera correctly will increase your chances of success. An exposure mode such as aperture priority is fine. But set a fairly small lens aperture like $f11$ to ensure plenty of depth of field.

Using a wide-angle or standard focal length lens will give a wide enough field of view to ensure that your subject is in the frame. Because

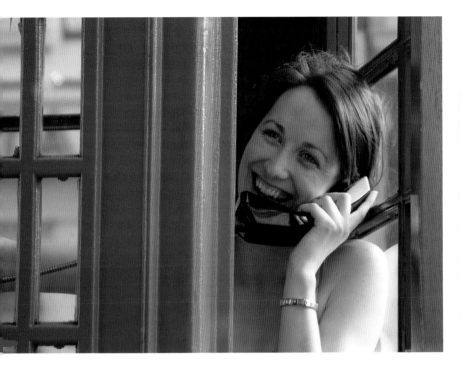

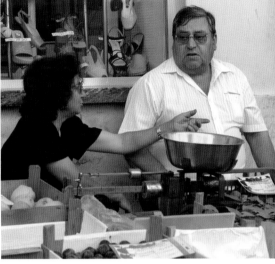

you do not know your focus zones, you cannot rely on autofocus. It is better to manually set the focus to 10 feet (3 m). This amount of focus and the small aperture will record most of the scene in sharp focus.

USE THE SURROUNDINGS

Showing some of a person's surroundings in your pictures lets you convey much more information to the viewer than you can with a straight portrait.

Environmental portraits use the elements within the scene to communicate something about the subject. You can be generous or reluctant with the information you communicate to the viewer simply by how you choose to frame the shot.

A woman using a classic English red telephone booth; the handset and her expression tell their own story.

Technically, a camera mounted on a tripod using available light will result in great, natural-looking results—even indoors. If there is a mix of lighting types, you may need to try different white-balance settings to get the best results. Alternatively, draw the curtains, and only use incandescent lighting, or rely wholly on daylight. Of course, if the light levels are very low, use a tripod and ask your sitter to hold perfectly still during relatively long exposures.

These subjects were shot at close range, but they clearly had more on their minds than photography.

Sports and action

Most of the time you will be taking photographs of subjects that are stationary or posing for you. But once you venture into the world of fast-moving subjects, the disciplines and demands on your camera skills are very different.

Basically, anything moving can be classified as action. It can be as simple as children playing on their bicycles, as fast-paced team sports, or as challenging as motor racing.

ACTION STATIONS

Even experienced photographers often find that action shots can be a technical nightmare because things happen very quickly, and they cannot be repeated.

Your first priority is to get to know the camera. Framing a landscape or family portrait is simple by comparison, because there is more time to think about camera settings and focusing. With action photography the time available to contemplate these factors is much

A shutter speed of 1/1600 sec is fast enough to freeze the fast movement of this roller coaster.

Captured at 1/320 sec, this shot works because the camera was panned to match the car's speed.

HOW TO PAN

Tracking your subject through the viewfinder as it passes in front of you is panning. Taking the picture with a reasonably slow shutter speed as you pan records the subject as sharp, while the background is attractively blurred.

Good panning takes practice, especially with a long telephoto lens and a very fast-moving subject. But the effect can be dramatic. It is worth trying a variety of shutter speeds, too. The ideal situation is a balance between a recognizably sharp subject and a blurred background.

more limited. It is, by its very nature, fast moving. And this means using your camera quickly and intuitively. You will often need to adjust focus and camera settings almost instantly to catch the action.

SPORTING LIFE

Of course, there are many forms of sports and action; the scenes you will be tempted to shoot will be influenced by what appeals to you. An affinity for a certain sport will help you take better pictures because you will be able to predict what is going to happen next.

All DSLR cameras have autofocus systems (but some speciality lenses do not). These are effective enough to keep up with more sedate sports.

Frenetic sports are the most demanding in terms of autofocusing.

Compared to high-speed machines, this run is relatively slow—a 1/125 sec shutter speed is all that is required.

DSLRs usually have three focusing modes: single shot, continuous, and manual. Continuous, or predictive, autofocusing can keep up with fast-moving subjects, although this depends on the effectiveness and efficiency of the camera's system. If you find that your DSLR is not very good at autofocusing on action, switch to manual focus. You will now have to physically adjust the focusing barrel to attain sharp focus.

There are two manual focusing techniques: You can track, or pan, with the subject through the viewfinder, adjusting focus and taking the picture when the subject is sharp. Or you could prefocus.

To do this, manually focus on a particular point—such as a mark on the track—and just a fraction before the competitor reaches that spot, press the shutter. Taking the picture an instant before the subject reaches your point allows time for the camera to perform several complex functions before the shutter takes the exposure. The amount of shutter lag depends on the camera, so you will need to experiment to learn how yours acts.

Nature

Capturing the beauty and glory of nature is extremely rewarding and a strong test of your camera skills. Of course, nature is a very broad subject, and the aspect of it that appeals to you is a personal preference. It might be the birds and insects in your garden, flowers, or animals in zoos or in the wild.

As a subject, nature is probably the most demanding in terms of lenses. Although it is possible to tackle most subjects with the lens that came with your camera, there is no doubt that you will need extra lenses to really enjoy this challenging genre of photography.

Like all wildlife this penguin minds its own business, and it can only be photographed from a concealed position.

FLOWER POWER

When shooting flowers, you usually have the option of shooting in their natural site or relocating the blooms indoors. Clearly, the latter is not always possible or desirable, but shooting outdoors can be difficult if the conditions are working against you. Sunny, windy days can be difficult because the contrast can be too high, and your subject will be swaying around too much to get a sharp image.

Days when a bright sun is gently diffused by high clouds often yield the best results. There is enough light to allow plenty of aperture and shutter speed choice, and it is diffused enough to keep the contrast down to manageable levels. Yet the light is still directional enough to bring out the delicate colors and textures of the flowers.

Early morning light often brings the best results. The low sun gives the light a warm quality that also highlights textures, and there is often dew to add an extra dimension. You can even use a water spray to introduce your own droplets.

There are plenty of techniques for successful floral images and camera positioning is an important one. Either step back and use a telephoto zoom to make the most of floral carpets of color, or move in close and zero in on

Getting close to this rose at $f4$ means that only the tips of the petals could be held in sharp focus.

a bloom or two. In both cases, you will have stronger compositions by using unfussy backgrounds because the colorful blooms can stand out.

If you move indoors, you can take control of the situation by picking only the best specimens. As for lighting, window light works well, but strong direct sunlight is harsh and contrasty. Diffused sunlight is the best; this can be supplemented by a sheet of white card stock to reflect the light.

Position this on the opposite side of the window to gently fill in any dense shadows.

Colored card stock can be a suitable background, but position it a good distance behind your subject so shadows are not cast onto it. A technique for realistic backgrounds is to take some out-of-focus photos of fields, meadows, and lawns. Get a few large prints made and use them as backdrops.

BUGS AND SMALL ANIMALS

The outdoor world has many interesting insects and tiny animals worth photographing. Their size means that you need a lens with a very good close-focusing (macro) ability to get a reasonable size subject in the viewfinder. To allow a comfortable distance between you and the subject—so you don't disturb it—a 150-mm or 180-mm telephoto macro lens is ideal.

Using close-up lenses is another option. Close-up lenses screw onto the front of the lens like a filter to allow closer focusing. They are available in a variety of strengths—expressed in diopters—and they are relatively inexpensive when compared to a macro lens. Close-up lenses are also clear, so there is no light loss. If you combine a +2 or +4 diopter close-up lens with a 70–200 mm telephoto zoom, you will have a reasonable magnification.

Keep in mind that getting in this close means that you need to watch the shutter speed. If you are using a macro lens close to the subject, dropping below a shutter speed of 1/250 sec is risky. To be on the safe side, use a camera support—but only if your subject isn't likely to flee before you take your shot.

This lionesss was captured on a safari at a focal length of 700 mm—a sensible precaution considering the nature of the subject.

A 257-mm focal length was enough to capture this robin feeding from a concealed position indoors.

If you do not own a macro lens but you want to try close-up photography, buy an extension tube. This fits between the camera body and the lens to enable closer focusing than normal. There are no glass elements within an extension tube, so the optical quality of the lens is not compromised. However, there is a slight light loss, which the camera meter will automatically take into account. Some tubes still allow autofocus, but it is usually a good idea to switch to manual focus.

LARGER ANIMALS

While a macro lens is essential to photograph insects and plants, you will need a telephoto lens to make the most of birds and mammals. In fact, you will often need something very long to take a decent picture of distant subjects. A long telephoto, such as a 300 mm or 400 mm lens, will not only provide a viewfinder-filling image of the subject, it will also help you crop away a messy foreground and background. This is especially helpful because it is obviously not possible to move wild subjects in front of a more attractive background.

A small focusing error or the slightest hint of camera shake will ruin a picture shot with a long lens. Therefore, it is important to double-check the focus, and stick with fast shutter speeds even if you are using a support. If lighting levels are insufficient for action-stopping shutter speeds, increase the ISO sensitivity until high speeds are possible. This will increase the level of digital noise, but it will be offset by sharp pictures.

Whether you are photographing at a zoo or on safari, you have to be ready to catch fleeting moments of interesting behavior. If you miss something, you may have missed it for good. Be prepared and shoot plenty of shots, and you will end up with many images that will make you proud.

Travel

Travel broadens the mind and provides the avid photographer with fresh and exciting challenges. Your subjects might be as diverse as people, wildlife, or landscapes, depending on the nature of your trip, so the advice on the previous pages will be useful.

Photographing a town, city, or location that is not known to you will almost certainly bring out your creative side, so you will need to be prepared for new discoveries.

PACKING FOR TRAVEL

Your approach to travel photography depends on your plans. Preparing your camera outfit for a safari requires a different equipment approach from a beach vacation in the sun where most of your pictures will be snapshots. For most travel photography, a DSLR with one or two lenses that cover a range from 28-mm wide-angle to 300 mm telephoto is ideal. You will be able to cover a broad range of subjects with fairly portable equipment.

While you will probably remember your camera and lenses, significant items such as battery chargers, memory cards, storage devices, and power outlet adapters are easy to overlook. Some forethought before leaving your home will save you anguish later. If you are a frequent traveler, it is worth assembling a traveling kit (see box) so everything you need to remember is in this bag. This requires spending some money upfront, but it will pay for itself in time.

BUYER'S GUIDE

Photographer's travel kit
The items you need depend on your level of photographic commitment, but the following important accessories may be helpful.

- **Power outlet adapters**
- **Power leads**
- **Multitool**
- **Notebook and pen**
- **Spare USB/FireWire cords**
- **Memory card reader**
- **Cleaning cloths**
- **Sticky labels**
- **Head lamp**
- **Battery charger**

This shot uses the haze to tell two stories. The foreground reveals a flavor of the place, and the background is the more traditional photographic subject.

SHOOT THE LESS OBVIOUS

It is natural to shoot well-known landmarks wherever you visit. For example, few people would visit, for example, New York without photographing the Statue of Liberty.

But an interesting aspect of travel is that the things that seem mundane and everyday to the residents are often new, unusual, and photogenic to the visitors. Markets, people going to work, cars, buses, and even road signs are all worth capturing. These are also the pictures that really sum up the spirit or flavor of a place or country.

Therefore, when you photograph the major landmarks, it is worth trying something different. For example, try shooting late in the day. The quality

This candid shot at a 370-mm focal length gives local flavor.

and color of the light will be much more attractive. Keep shooting as it gets darker, too.

Timing when you take your photographs is important, and there is no doubt that the most photogenic light occurs at both ends of the day. However, a travel schedule is unlikely to perfectly match your photography, so expect to make compromises.

For pictures of people, using the camera's flash unit can lighten heavy shadows—even a blip of flash can add a highlight to the eyes. It is worth testing the camera's fill-in flash feature before you go to see how it performs. It may release too much flash, but this can be controlled by using the flash exposure compensation feature. Setting -1 gives good results on many cameras, but try it on yours first.

When shooting people who have dressed up for tourists, a small tip—or perhaps buying an apple—is expected.

The exotic coloring in this African garb tell much more about the place than a few drab landscapes.

Architecture

Most people live—and many of us work—in buildings. And while you would not point a camera lens at most of them, there are plenty that deserve to be photographed. Whether they are historic or new, constructed from glass, steel, or stone, lived-in or derelict, examples of architecture in its myriad forms can be rewarding subjects for the camera.

Interiors

Building interiors will test a camera's white-balance system. There might be a mix of natural daylight and artificial light sources, and this can lead to unusual color reproduction.

Try the camera's automatic white-balance setting at first but be prepared to switch to a preset. Another option is to set a custom white-balance using one of many accessories available, such as an ExpoDisc, to get a reading. A workable result also can be obtained by photographing a sheet of white paper in the prevailing light.

The photographer was shooting with a shutter speed of 2.5 sec; the subjects in this interior were asked to remain as still as possible to avoid blurring.

EVERYWHERE YOU GO

You are surrounded by buildings, in the town or city where you live or any that you may visit, and many are worth photographing, but you may not have appreciated them before. Try to see your hometown in a new light by shooting a self-imposed photo project. For example, if there is a new local construction, take photographs from the same spot at regular intervals to show the work as it progresses.

There are plenty of architectural themes that can be explored with the camera. You could try a broad subject such as cathedrals, something artistic, such as reflections, or shoot a concept based on house numbers. Themes give you an extra purpose, as well as encourage you to keep your eyes open.

GOING HISTORICAL

Modern architecture has its own appeal, but it is fair to say that most photographers prefer historic buildings and structures packed with character.

As with any scenic subject, it is the quality of light that makes the difference between good and average pictures. You are obviously at the mercy of the building's position, so be sure to figure out where to place yourself before shooting.

Bland, overexposed, empty skies need to be avoided with most

subjects, but this is even more important in architecture. Use a filter such as a polarizer to give the sky some tone or, if the sky is beyond help, try a composition that will minimize its influence on the final result. Using a telephoto zoom and picking out details in the architecture are other options to try.

TRY SOMETHING DIFFERENT

Some of the most fascinating building pictures are taken when light levels fall. A modern office building can look ordinary in daylight, but once the interior lights come on, the scene can be transformed. The best time to shoot is in the hour after sunset when there is still color in the sky. After this point, the mix of black sky and urban light pollution does not look very uplifting.

In poor light, the camera has to set a longer shutter speed, so you will need a tripod. Very long shutter speeds are worth trying when there is traffic moving in the frame because car lights record as lines of color, which can look great.

This contemporary structure in Orlando, Florida was captured through a polarizer. The roof is framed by a blue pillar.

This brightly lit station roof is captured at ƒ11, keeping everything in sharp focus and making the shapes the main subject.

London's "Gherkin" tower reveals its interesting structure when the offices are lit in the early evening.

Shooting in low light

When the light starts getting low and darkness beckons, the first instinct is to switch on the camera's flash. In fact, many digital SLR cameras in auto mode command the flash to automatically pop up and fire. This is very useful and convenient if you are taking a few family snapshots, but the photographic results are rarely anything special.

SET A FASTER SPEED

Film has one basic sensitivity, so if the light conditions demand a slower or faster film, it needs to be unloaded and replaced. Digital offers a much more convenient, faster, and cheaper solution. All you have to do is enter the camera's ISO function and set a more suitable sensitivity.

The necessary ISO setting is governed by several factors. Basically, the darker the conditions, the higher the ISO rating if you wish to shoot with a handheld camera. If you have a tripod, you could continue to shoot at a medium ISO speed for optimum image quality.

 DIGITAL NOISE

When an imaging sensor converts any light striking it into an electronic charge, it causes a small amount of heat to be generated, too. The longer the exposure, the greater the amount of heat created, and this is accompanied by digital noise. The issue is exacerbated at higher ISO settings because the image signal is amplified, along with any flaws that may be present.

This picture was captured with a tripod using a 30-sec shutter, which was enough time for the moonlight to register at ISO 200.

Setting a high ISO of 3200 makes it possible to capture an image in just 1/8 sec in candlelight. But there is more digital noise—a grainy effect—as a result.

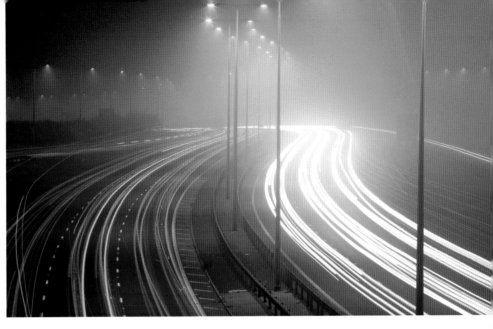

The long shutter speed needed in low light can be used to your advantage; it records the streaks of a cars passing as stylish trails that would not look as appealing otherwise.

If you are shooting at slow shutter speeds with a handheld camera, you are also risking camera shake. How slow you can successfully handhold a camera is personal, depending on camera technique, medical conditions, and of course, the focal length of the lens in use. With a lens of 50mm or shorter, shooting sharp pictures at speeds as slow as 1/30 sec is possible. Leaning against a wall or supporting the camera on a wall, streetlamp, or something solid may allow you to go as low as 1/15 sec or 1/8 sec.

THE RIGHT COLORS

Low light can have unfortunate consequences for auto white-balance performance. You may have better results by taking manual control. This especially applies to outdoor shooting with indoor artificial lighting.

It is generally true that most cameras deal better with interior lighting in a preset mode. Therefore, in an office or store environment, the fluorescent preset should be used, and try the incandescent or tungsten setting at home shots. Because tubes and lamps vary wildly, do not be surprised if you still get pictures with an overall color cast. Sometimes this can suit the image, but often it is undesirable.

Another option is to shoot Raw format and correct any color balance issues during processing. This is very flexible and will save time while shooting although you will spend more time image editing at your computer.

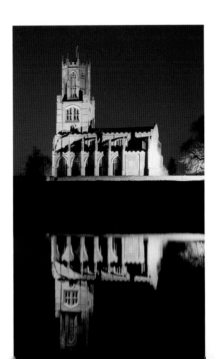

This shot was manually tweaked because the camera's automatic settings made the church building too yellow.

Basic
Image Editing

Get organized

Shooting photographs is challenging, creative, and fun. This also applies to editing them on the computer and creating your final results. However, there are a few intermediate steps in between that are a little dull; there is nothing more to them than following a few mechanical procedures. But these steps are important if you want to keep track of your pictures and work in a logical, time-efficient way.

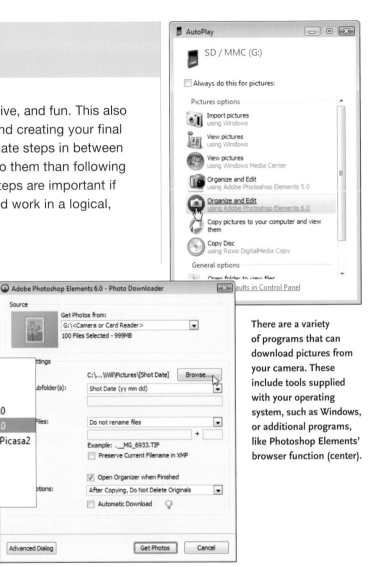

There are a variety of programs that can download pictures from your camera. These include tools supplied with your operating system, such as Windows, or additional programs, like Photoshop Elements' browser function (center).

DOWNLOADING IMAGES

The first step in the process is to download the digital photographs from the camera's memory card to the computer. Your DSLR camera can be connected via its USB port to a computer with the supplied card. Or the memory card may be removed and placed in a card reader (see page 28), which is usually faster.

Even more convenient than a card reader is using a computer equipped with a suitable memory card slot.

You can insert a memory card and automatically the download will start, depending on the setting in the *Autoplay* dialog box. You may prefer that your downloads and picture files be organized automatically by your

image-editing software. Or you can download your image files manually, placing them in folders that you have created and labeled according to your own system.

If you use an Apple Macintosh computer and don't want to use the default choice of iPhoto, you can use the *Image Capture* tool in *Utilities*.

FOLDER SYSTEM

One system to consider is creating a folder for the year. Within it can be folders named with the month and date followed by the event, location, or subject. Folders can be organized chronologically, which makes pictures easier to find.

Nested within each folder can be more folders, labeled: "1 Raw," "1 JPEG," "2 Converted," "3 Work in progress," "4 To print," and "5 For archive." There are two folders with "1" in their name because originals can be either Raw or JPEG files, and the number denotes the processing stage of the images. When you download your pictures, you must place them in the appropriate folders.

There are times when you may shoot Raw and JPEGs together—the camera saves both. JPEGs are faster to view; Raw files provide the best image quality. So once you have decided which pictures to print, be sure to use the Raw file. The Organizer browser in Photoshop Elements lets you rate your pictures so it is easy to prioritize photographs.

Converted Raw images can be stored in the "2 Converted" folder until you are ready to work. Once you have started, images are moved to the "3 Work in progress" folder and stay there until they have been cropped, retouched, and prepared for printing.

At this stage finished images can be moved into either the "4 To print" folder or the "5 For archive" folder. You can then build up a collection of files in the "4 To print" folder and, when you have finished, copy this folder to a CD to take to a printing service.

This is a straightforward, no-frills, logical workflow that leaves the original files untouched. And you will have images ready to print or use for other purposes, such as a slide show.

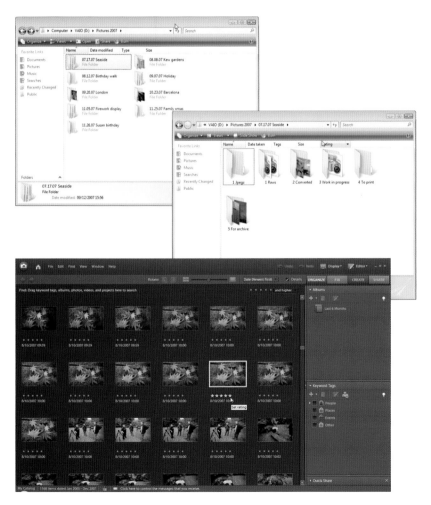

You can sort photographs using directories or folders in Windows (above) or display them by using Photoshop Elements' browser (left).

Image-editing software

Your DSLR camera comes with software, and its capabilities depend on the model you own. It most likely allows image browsing, simple corrections such as red-eye removal, and perhaps some creative techniques.

However, to really get the most from your photography, it is worth investing in a dedicated image-editing program. Image-editing or manipulation software is available in a range of price levels. The expensive Adobe Photoshop CS-series is aimed at advanced and professional photographers.

Elementary photography

For the examples in this book, Photoshop Elements is used. It is a popular, easy-to-use program that offers a variety of tools from the Photoshop CS-series edition at a good price. Moreover, because it is widely used, there is plenty of technical and tutorial support available.

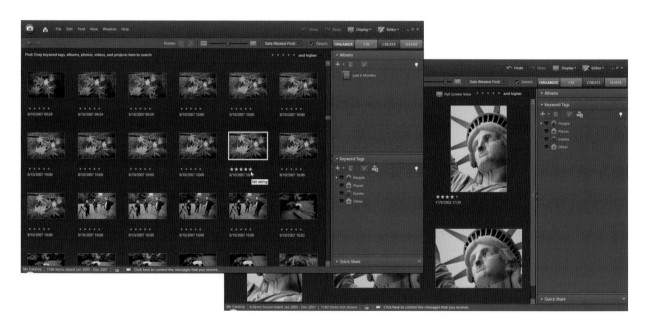

BROWSER TOOLS

Photoshop Elements is designed to offer a logical workflow for your pictures. It allows you to conveniently import and catalog original files, process and edit them creatively, and then finally print or share your images.

When you are organizing your pictures, the browser gives you many options, including varying the thumbnail size to see larger previews, view several pictures at once, rotate images, and rate them with zero to five stars.

Photoshop Elements has two main modes: the browser and the image-editing mode. The browser allows you to look through your photos like an electronic catalog and add details such as star ratings or captions. The image-editing mode enables you to edit your photos using different software functions.

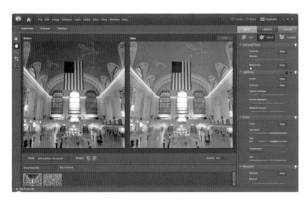

One of Photoshop Elements' editing features is the *Quick Fix* mode, which shows you *Before* and *After* views of your change.

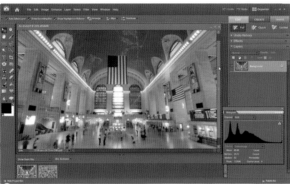

You can also correct individual areas by using the tools in *Full Edit* mode.

Photoshop Elements' *Undo History* window records your changes so you can go back and correct mistakes.

IN CASE YOU GO WRONG

Think of the *Undo History* function as a very versatile security blanket. If something goes wrong when you are enhancing an image, use *Undo History* to go back a step or two. Or you can go back to the beginning at the click of the mouse. The default setting in this software allows 50 history states, and you can increase it if necessary.

FIX AND QUICK FIX

To begin editing, click on the *Fix* tab. You will find several automated image-correction functions. These are handy if your time is limited or you are working on a batch of snapshots. However, for important images, opt for either the *Quick Fix* or *Full Edit* options. The *Quick Fix* menu will do a respectable job, and the ability to see the *Before* and *After* views is helpful. However, it does not have the breadth of the *Full Edit* option.

FULL EDIT

The power and flexibility of Elements is clear in the *Full Edit* interface. There is an impressive array of tools to adjust exposure, make selections, and clean up photographs. And that is just the beginning. There are also many artistic filters that photographers of all abilities enjoy.

Clicking on Windows in the *Toolbar* will reveal your options. For most images the *Undo History* and *Layers* panel are the most useful windows to keep on your screen. You can call up the others when they are required.

Elements' *Share* menu helps you quickly distribute your finished masterpieces.

SHARE YOUR PICTURES

Elements has many output options. After editing, enhancing, and improving your photographs, you can print, via an Internet vendor or a desktop printer, or share them with family and friends.

Raw processing

Shooting in JPEG results in high-quality photographs that can be viewed and printed straight from the camera. And because JPEG files are highly compressed, they take up less space on the memory card, which means you can shoot more pictures. However, when a JPEG is made, a large amount of data that is hard to see is discarded. Raw preserves this data, so it is possible to make more changes later without damaging the image quality.

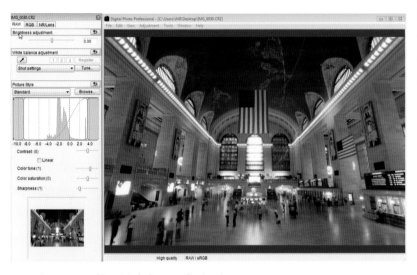
High quality RAW / sRGB

A Raw image opened in Digital Photo Professional reveals the picture as it was exposed in the camera.

TAKING ADVANTAGE OF RAW POWER

In Raw format, characteristics such as white-balance and hue can be adjusted. You can even change the exposure within a few stops.

An obvious advantage to using Raw conversion software is that the original capture information from the camera remains untouched. You can revisit the image anytime in the future and make new adjustments. For your convenience, most Raw converters have a batch-processing feature that processes many images at one time. But on the downside Raw files take up more storage-card memory, and they cannot be viewed or used straight out of the camera—they need to undergo the digital processing stage on a computer.

Convert from Raw

There is plenty of Raw conversion software available. You probably received a package with your camera, or you can buy a third-party Raw processor, such as Bibble, Capture One, DxO Optics Pro, or Digital Photo Professional.

Elements' Raw converter is called Camera Raw, and it is regularly updated as new digital cameras arrive on the market.

Raw converters allow the option of 8-bit or 16-bit file conversion. Working in 16-bit provides the best image quality and the most colors, but it is not fully compatible with some image-editing software, such as Elements. So if you do convert Raw files to 16-bit TIFFs—an alternative image format to JPEG that preserves all data—they must change to 8-bit using *Image>Mode>8-Bit/Channel* before continuing.

Characteristics such as exposure, white-balance, and the overall image tone can be corrected and fine-tuned. Some Raw converters offer additional features, such as noise reduction and lens aberration correction.

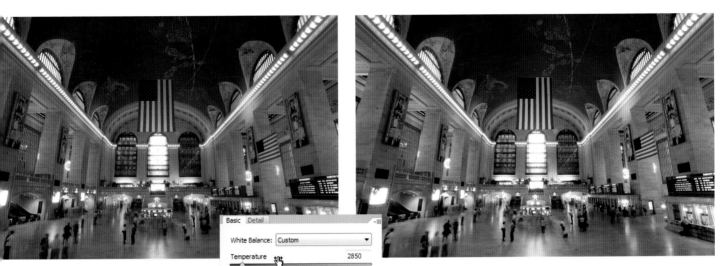

OPEN THE IMAGE

Open the image in Camera Raw and you will see a large preview image with controls on the right side. Changing any of these sliders will alter the preview image in real time so you can see the possible effect.

White Balance: Custom

Temperature | 2850
Tint | +20

Auto Default

Exposure | +0.65
Recovery | 3
Fill Light | 0
Blacks | 5
Brightness | +50
Contrast | +25

Clarity | 0
Vibrance | 0
Saturation | 0

DO THE CONVERSION

New York's Grand Central Station is dominated by tungsten lighting, which made this image look very orange—even with auto white-balance on. To correct this, the white-balance and tint were changed.

The slightly underexposed image was also recovered using the *Exposure* slider. Clicking *OK* improves the results in a few seconds. The corrected image can be saved as an ordinary JPEG or TIFF file to use however you choose.

Adobe Digital Negative format

One disadvantage of Raw shooting is that each camera maker has its own proprietary format, and that format can vary from model to model.

To alleviate the problem, Adobe has introduced the Digital Negative (DNG) format. It is an open and publicly available format to all camera and software manufacturers so that files can be easily processed, even in the future. As yet, however, the adoption of DNG as an open standard by camera manufacturers has been limited, and file sizes still tend to be very large.

Quick-and-simple editing

Elements offers *Full* and *Quick* edit functions. There is also a *Guided Fix* option, which explains what to do as you work.

Quick Fix features a small tool palette with four correction options: *General Fixes*, *Lighting*, *Color*, and *Sharpen*. All of these categories have an *Auto* option, with sliders for manual control. The *Before* and *After* results are shown onscreen, for convenience. And you can always return to the original shot if you don't like the change.

The most essential manual fixes, like trimming the picture with the *Crop* tool or removing dust and scratches by cloning, are discussed in the next few sections in more detail.

GENERAL FIXES

The *Smart Fix* function corrects color casts and improves highlight and shadow details. The *Smart Fix*'s *Auto* option effectively sets the strength, so it is worth a try. And if you choose the manual option, be sure to move the *Amount* slider delicately to avoid making the effect too strong.

The *Red Eye Fix* is self-explanatory—just one button to click—and it does not have a manual override. If it cannot solve red-eye, try the tools in *Full Edit* mode instead.

LIGHTING

Auto Levels adjusts contrast and colors, while *Auto Contrast* adjusts only contrast. However, there is a great deal of control in the *Lighting* menu, and you may prefer the flexibility of the three manual sliders.

Shadows need some depth, and highlights need to sparkle; otherwise, an image can look very flat, dull, and lack contrast. Whenever you are using corrections featured in *Quick Fix*, try not to be overzealous with the sliders.

COLOR

The *Auto* button improves color and contrast, but it also needs a subtle touch. The *Saturation* slider has a wide range so you can convert images to black and white by setting it down to the lowest position. However, there are better ways to make more striking black-and-white conversions, which are discussed later in this book. The best way to use this tool is to make small adjustments to the sliders and use the instant feedback from the *After* window.

Before *Quick Fix* is applied, the image is too dark and lacks contrast.

SHARPNESS

The *Sharpen* function is based on a traditional photographic technique that is used to optimize image sharpness and detail rendition. All digital files will benefit from the *Sharpen* function to some degree, but its purpose is to enhance images for print or display. The most important aspect of using this function is not to overdo it. But keep in mind that *Sharpen* will enhance an image's sharpness, but it cannot rescue a blurred, out-of-focus photograph.

Also remember to set the *Zoom* to exactly 100 percent, because the effect is applied at a pixel level, regardless of the size of the image in megapixels.

ENTER *QUICK FIX* MODE

With the image open, click on the *Quick Fix* button. At the *View* option (a drop-down menu) at the bottom left corner, select the *Before & After* option. There are also the options of *Horizontal* and *Vertical* positioning.

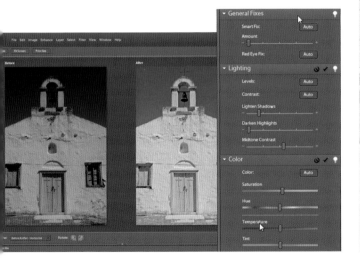

After *Quick Fix* is applied the image appears lighter and warmer.

MAKE THE CORRECTIONS

The image is slightly dark and a bit cool. The *Lighten Shadows* slider was moved to the right to lighten the entire image, and the *Midtone Contrast* was adjusted very slightly. The *Color Saturation* and *Hue* sliders were moved to the right to add some warmth.

Cropping for impact

The same picture can often be cropped in different ways and for different reasons. You might want to trim unwanted elements from the edge of the picture or change the visual focus.

The *Crop* tool's *Tool Options* bar offers a full range of options so you can crop to a preset image size or set a custom size in inches or centimeters with a suitable resolution. You can also crop without restriction if you prefer.

The original picture is a nice composition, but the surfer is lost among the posts.

1 CHOOSING CROP SETTINGS

Select the *Crop* tool from the *Toolbox*. You can immediately define your crop by clicking and dragging over your chosen area of the picture. However, if you want the final image to keep the same proportions, choose the *Use Photo Ratio* option from the *Aspect Ratio* menu on the *Tool Options* bar.

2 CHANGING FORMAT

To switch from a landscape format to a portrait, click on the *Swap Dimensions* button between the measurements in the *Tool Options* bar.

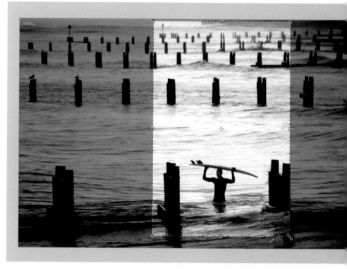

3 MAKING THE CROP

Place the cursor at the top left of the image. Click and hold on the image and then drag the cursor down toward the bottom right corner. The cropped image is defined by a broken dotted line known as marching ants. If your first attempt is not accurate, the crop can be modified quickly and easily by dragging the corner markers. Or you can press the Esc key and try again.

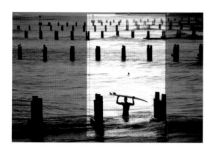

④ ADJUSTING THE CROP

Click in the center of the crop to reposition it. Click the green checkmark in the lower right to accept the changes.

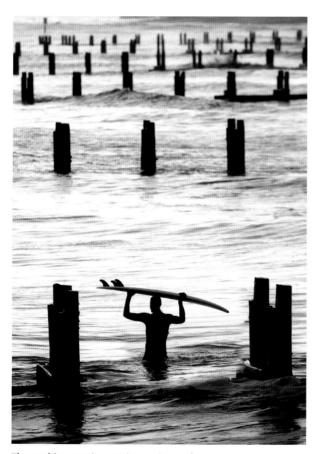

The resulting crop is more interesting, and the surfer is easier to see. Because the posts are so repetitive, nothing is lost.

Correcting horizons

Before cropping a picture, it is worth looking at the horizon first. Obviously, this does not apply to every picture, but it is important with landscapes and coastal scenes.

Crooked horizons never look right, but the *Straighten* tool (shortcut key P) will correct this fault. Click on one side of the horizon and then draw out a line to another point on the horizon. Click again, and the software automatically does the rest. It is a simple, quick fix.

Afterward you will need to use the *Crop* tool to trim away the excess edges.

The camera wasn't held level, and the result is an uneven horizon, that spoils the picture.

After cropping, the horizon appears level, which is much more pleasing to the eye.

Cloning for clean images

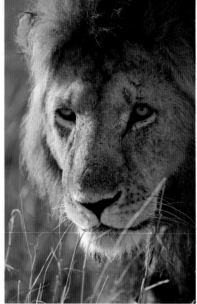

The *Clone Stamp* tool allows you to copy, or clone, a portion of an image and paint it onto any other part of the image. It is perfect for removing distracting sections and repairing blemishes and flaws.

Image imperfections can also be corrected by using the *Healing Brush* and the *Spot Healing Brush* tools—they can be quicker to use than the *Clone Stamp* tool. With these tools the software does much of the work.

Cloning will eliminate the blades of grass obscuring the lion's face.

Healing brushes

With the *Healing Brush* tool, you can sample an area, and the software will match the texture, lighting, and transparency to the healed region.

The *Spot Healing Brush* tool does not require sampling. By choosing a brush that is a little bigger than the area you want to retouch, the software automatically samples from around the retouched area. It is a great tool for retouching small facial blemishes and flaws in even-toned areas such as the sky. For larger areas the *Healing Brush* is probably better.

GET READY TO CLONE

Open the image and make a *Background* copy by right-clicking on the *Background* layer in the *Layers* panel and choosing *Duplicate Layer*. Select the *Clone Stamp* tool. Start by selecting a suitable brush. Right-clicking on the image brings up the *Default Brushes* menu—also available in the *Tool Options* bar—and clicking on the drop-down menu reveals many more options.

2 START CLONING

With a suitable brush—and you may need several types—place the cursor on the part of the image that you want to sample. A crosshair target will appear. Left-click while pressing the Alt key (⌥ on a Mac). Use the Ctrl (⌘) and "+" and "–" to zoom into the image for a good view of your working area.

4 USE THE UNDO HISTORY

Take your time and use the *Undo History* to go back a step or two if there are obvious signs of cloning. Once your cloning is done, go to *Layer>Flatten Image* to merge the duplicate layer with the original. Afterward save your file.

3 SAMPLE AWAY

Now just left-click and paint over your chosen area. A 400 percent magnification was used as well as a tiny brush to work around intricate details.

In the *Tool Options* bar the *Opacity* controls the density of the clone. The default is 100 percent, and using a slightly lower setting gives an almost invisible result—especially in areas of even tone.

After cloning, it appears as if the grass were never there.

Adjusting levels

Getting accurate exposures is obviously very important, and modern camera meters are very reliable. But even perfectly exposed images that have been correctly processed can be improved with the *Levels* feature.

The *Levels* histogram is a graphic representation of the tones within an image. In an 8-bit color image there are 256 shades of tone in each of the three color channels: red, green, and blue. Level 0 is black, and level 255 is pure white.

In a fully toned image the histogram will probably build up to a peak in the middle and taper off in the shadow and highlight regions. A predominately dark image will have its peak toward the left side of the histogram, while a light-toned image will have its peak on the right side.

The *Levels* adjustment will fine-tune this exposure and provide brightness and contrast.

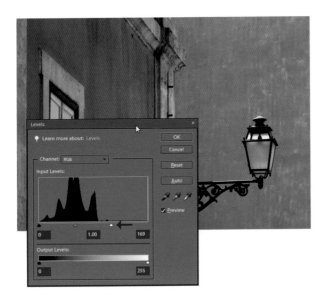

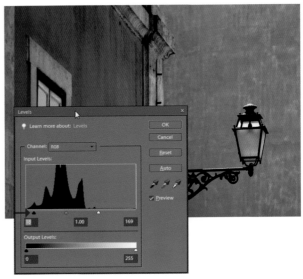

① START WITH THE WHITE POINT
Locate *Levels* by clicking on *Enhance>Adjust Lighting>Levels*. Click on the white arrow, and move it to the left toward the beginning of the graph. The image will lighten up.

② NOW ADJUST THE BLACK
Click on the black arrow immediately beneath the histogram and move it to the right. There is already some black information in the image, but shifting the arrow to the right increases it to give the image greater depth.

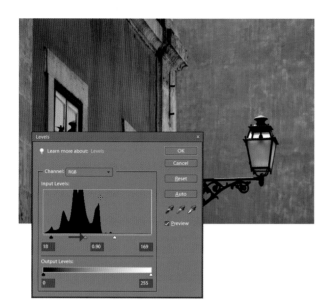

Correcting color casts

Any major inaccuracies in color reproduction ideally need to be resolved at the Raw processing stage with the various white-balance controls. However, minor adjustments often still have to be made.

Of course, if you shot in JPEG format, it is only at this stage that corrections can be made, because there is no Raw conversion stage. In Elements the most flexible tool is the *Color Variations* dialog box, accessed by going to *Enhance>Adjust Color>Color Variations*. This tool will minimize color casts and adjust saturation.

You can remove a color cast by going to *Enhance>Adjust Color>Remove Color Cast*. Clicking on an area that should be white, gray, or black will adjust the image to make it neutral. This tool works, but it is not totally reliable. Therefore, the *Color Variations* tool is often preferred.

③ ADJUST THE EXPOSURE

The image already looks much better than the original; the final tweak is the *Gray Midtones* slider. Moving this to the left lightens the image, and shifting to the right darkens it. Click *OK* to confirm and save as usual.

Adding brightness and contrast enhances
this once flat-looking, lifeless image.

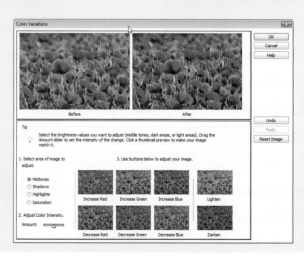

Resizing and resolution

After some basic adjustments the file can be saved for printing or additional enhancement. Some worthwhile techniques to keep in mind are resizing and interpolation. It is rare to use an image at its nominal size straight from the camera. Usually resizing will be necessary, and this can happen in many different ways.

IMAGE SIZE

A 10-megapixel DSLR used in Raw or its highest JPEG resolution will result in an image measuring approximately 12 × 8 inches (32 × 22 cm) at a resolution of 300 pixels per inch. But resolution is just a label applied to an image by the camera. The same image's dimensions would be doubled to 24 × 16 inches (64 × 44 cm) if the resolution was halved to 150 ppi.

If you wanted to keep the same image size but reduce the resolution to 150 ppi, then you would have to discard any unnecessary information, and the result would be a 2.5-megapixel image. The effect is improved by digitally averaging the data from all the pixels as it is compressed—a process known as interpolation.

However, if you want to increase the resolution, or increase the size and keep the resolution the same, the interpolation has a much harder job because it can only fill the gaps using averages based on the original data. Therefore, it tends to soften sharp edges.

Changing the values in this box alters the overall number of pixels in the image.

This symbol means that your changes will be proportional and your image will not look stretched.

Image Size

Learn more about: Image Size

OK

Cancel

Help

Pixel Dimensions: 28.7M

Width: 3872 pixels

Height: 2592 pixels

Document Size:

Width: 32.78 cm

Height: 21.95 cm

Resolution: 300 pixels/inch

☑ Scale Styles

☑ Constrain Proportions

☑ Resample Image: Bicubic

Unchecking the *Resample Image* option means that you can alter only the resolution of your picture, not the actual pixel data.

Altering any of the values in the *Document Size* will change the overall size of the picture.

RESOLUTION

The top and bottom images on this page have genuinely higher or lower resolutions. But horizontally the picture has been interpolated. The only image that really suffers in quality is the one which was interpolated upward. The file size as an uncompressed TIFF is calculated based on the total number of pixels.

300 ppi resolution
2 × 1.5 inches (52 × 38 mm) printed
600 × 450 pixels
810 KB uncompressed

**150 ppi resolution interpolated down
50 percent**
1 × 0.75 inches (26 × 19 mm) printed
150 × 112 pixels
51 KB uncompressed
(The surrounding area is not part
of the calculated size.)

150 ppi resolution
2 × 1.5 inches (52 × 38 mm) printed
300 × 225 pixels
202 KB uncompressed

**150 ppi resolution interpolated up
to 200 percent**
4 × 3 inches (104 × 76 mm) printed
600 × 450 pixels
810 KB uncompressed

Notice that if you reduce the size—as from the center image to the left image—the quality is the same. However, scaling it up from the same information results in reduced quality, forcing the computer to guess what the missing data would look like.

75 ppi resolution
2 × 1.5 inches (52 × 38 mm) printed
150 × 112 pixels
51 KB uncompressed

Creative
Editing Techniques

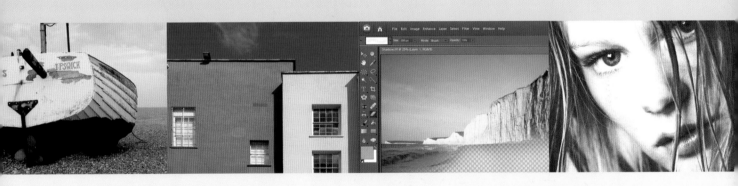

Coloring the sky

The difference in brightness between the sky and the foreground can sometimes be so great that the imaging sensor cannot record enough detail in both regions without help. When you are shooting, you can use a graduate filter to control contrast, but this is not always possible.

The *Gradient* tool allows you to add the effect digitally in a much more flexible way. Because you can introduce any color you want and alter the shape of the gradient, it has several advantages over camera filters.

Original image without gradient

Create New Layer button

Foreground to Transparent

Gradient Preview

Gradient Editor

Clicking on *Edit* or the *Gradient Picker* window brings up the *Gradient Editor*, which offers even greater control. As you get experienced with the *Gradient* tool, you may want to design different effects to suit your photography style.

In this example the *Opacity Stop* has been moved to the right to provide a dense gradient over more of the image.

It is worth experimenting in the *Gradient Editor* to see what is possible.

1 CREATE A NEW LAYER
In the *Layers* panel, click the *Create New Layer* button—the far left icon at the top of the list of layers. This will allow the gradients you draw to be switched on or off without affecting the original image. The original is automatically turned into the *Background* layer when you start.

2 CHOOSE A GRADIENT
Select the *Gradient* tool in the *Toolbox*. Next, go to the *Tool Options* bar at the top of the screen and click the arrow next to the *Gradient Preview*. This selects the *Gradient Picker*. Choose the *Foreground to Transparent* option, which is the second one from the top left.

3 SET THE OPACITY

In the *Tool Options* bar, click on the arrow next to *Opacity* and a slider icon will appear. Adjust this to 60–70 percent. This controls the intensity of the effect. This percentage might not suit your tastes, but you can always go back and change this by altering the layer's opacity in the *Layers* panel.

5 ADD THE GRADIENT

With the *Gradient* tool cursor, click and hold at the top of the image and draw a straight line down, releasing the mouse about halfway down the picture.

It is unlikely that you will get the perfect effect the first time, so use *Undo History* and try again. To reduce the strength, use the *Opacity* option in the *Layers* panel.

4 SET YOUR COLOR

In the *Tool* palette, check that the foreground colors are suitable for creating a gradient. The default settings are a black foreground and a white background. Pressing the D key resets the default colors. If you want a color, click on the *Foreground Color* window and you can select a different foreground color. For example, blue often suits a landscape.

Final result with gradient applied. Gradients were added from the corners and from below. Adjusting the *Opacity* in the *Layers* palette can vary the intensity of the effect.

Soft and dreamy

Adding a touch of dreamy soft-focus can provide atmosphere to some photographs, especially still-life and portrait shots.

Diffusion can be added to an image by shooting with a soft-focus filter on the camera lens. The photograph's light mood will be enhanced by a little overexposure. Of course, doing this while shooting means that if you change your mind later and want a normal, sharp image, you do not have that option. Therefore, it makes sense to add diffusion afterward on the computer, where you can apply soft-focus to any of your photographs.

The original picture of a red tulip in sharp focus.

DUPLICATE LAYERS
Copy the *Background* layer by dragging its name to the *Create New Layer* button. When it appears, click on the new layer's name to edit it and rename it "Soft focus."

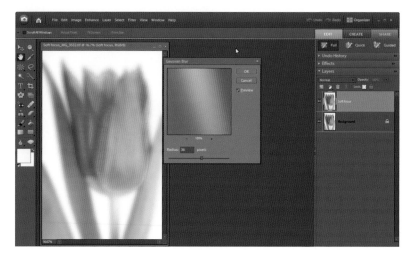

START THE EFFECT
The new layer needs to be highlighted in the *Layers* panel. Go to *Filter>Blur>Gaussian Blur*. In the *Gaussian Blur* dialog box, make sure the *Preview* box is checked so you can see any changes as you make them.

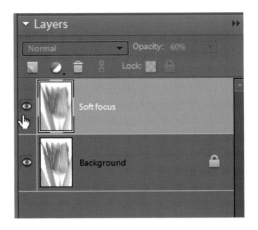

3 ADD THE BLUR

Click and hold the slider under the *Radius* window. Moving it to the right increases the amount of blur. The amount of blur you introduce depends on the image and how strong you want the result. In this image 36 pixels were added. Click *OK* to confirm.

5 SAVE THE IMAGE

In the *Layers* palette, clicking on the *Eye* icon next to the *Soft Focus* layer reveals the sharp layer below so you can compare the two images.

Finally, go to *Layer>Flatten Image*, and then to *File>Save As...* to leave the original untouched (see step 4 page 139).

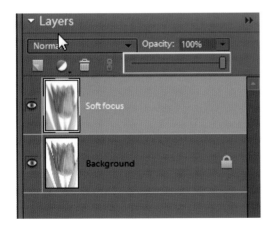

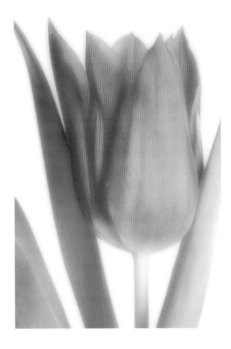

4 CONTROL THE EFFECT

You now have a blurred image in the top layer and the sharp original below. Go to the *Layers* palette and click on the arrow next to the *Opacity* to bring up a slider control. Click on this and move it down from the 100 percent setting. As you do this, the image appears sharper. In this example, a 60 percent opacity had nice results.

After diffusion the tulip still has the distinct lines of sharp focus, but it is now softened by the halolike glow of the partially transparent soft-focus layer.

Keeping buildings upright

If you point a lens up or down so that the camera back is no longer parallel to the subject, you will see the effect of converging verticals. This most commonly occurs when photographing tall buildings from ground level. Trying to get the top of the building in the frame usually means angling the camera upward. Unfortunately, doing so makes the building appear to lean backward.

This photograph has converging verticals that are very obvious at the left- and right-hand sides of the image.

There are several ways to avoid converging verticals when you are shooting: You can raise the camera position so the camera back is parallel to the subject, you can move farther away from the subject so you do not have to tilt the camera up at all, or you can use expensive perspective control lenses.

However, it is also possible to correct the effect on your computer using the *Transform* tool.

1 DUPLICATE THE LAYER
Open the image, then go to the *Layers* panel and drag the *Background* layer onto the *Create New Layer* icon to make a *Background copy*. This is necessary because the *Transform* tool will not work with a single-layer picture.

2 MAKE ROOM TO WORK
You will need some work space around the picture. Click on the *Zoom* value in bottom left and choose a smaller percentage from the pop-up list.

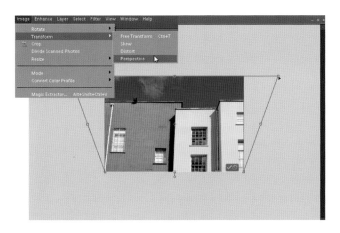

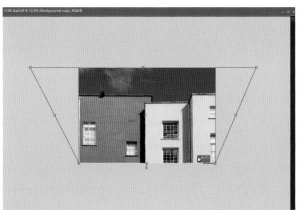

3 THE CORRECT PERSPECTIVE

Locate the *Transform* tool via the menu by choosing *Image>Transform>Perspective*. Click on the right corner with the cursor and drag it out sideways until the right side of the building is vertical. You will see the same amount of movement occur on the opposite side, but in this example the left side is still not vertical.

4 FINE-TUNE

To compensate, you can drag the central handle slightly to the left so that the central building is vertical. The left and right handles can then be pulled slightly outward (or inward) until all of the buildings in the picture are vertical. Accept the changes by clicking *OK*.

The final image appears as though the shot was taken directly across from it.

Warm and cozy

Photographs that have a gentle overall orange-brown tinge have a more welcoming, friendly appearance than those with a cool or blue color cast.

 If you take photographs when the sun is low in the sky and the light is warmer, it will be reflected in your pictures. Of course, you are not always able to photograph early in the morning or late afternoon, so why not rely on your computer to warm up your images?

 In Elements warmth can be added quickly by using the *Adjust Color for Skin Tone* tool, found under the *Enhance>Adjust Color* menu. An alternative method, which offers more choice, is the *Levels* tool.

The original image, taken in mid-afternoon, has a cool blue tone.

① START A NEW LAYER

In the *Layers* panel click the *Create New Adjustment Layer* icon and select *Levels*. Adjustment layers have the same effect as selecting the equivalent tool from the *Enhance* menu. However, a layer can be switched off at any point without affecting the original. Or the effect can be altered later.

② MAKE ROOM TO WORK

If necessary, move the dialog box to one side so you can see your picture. If you have the *Preview Option* checked, your adjustments will be instantly reflected on your picture.

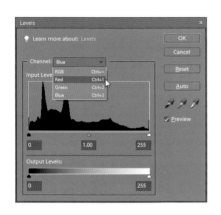

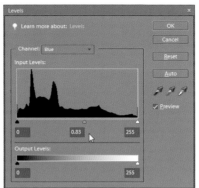

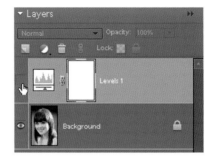

③ ADD SOME RED

Click on the *Channel* button to reveal a drop-down menu, and choose the *Red* option. This allows you to alter only the red tones as you adjust the sliders beneath the histogram.

⑤ NOW FOR SOME BLUE

Click on the *Channel* drop-down again and select *Blue*. Click on the gray arrow in the histogram and move it to the right. You will see the red color cast fade a little and change to an overall orange hue. Stop when you have the desired result. Go back to the *Red* channel and tweak it if necessary. Click *OK* when you are satisfied.

⑥ COMPARE RESULTS

You now have an image with an original and an adjustment layer. Go to the *Layer* palette and click on the *Eye* icon next to the *Adjustment* layer. This icon disappears and the layer is switched off, so it has no effect on the original below and you can make a quick comparison. Double click on the layer if you want to make additional changes.

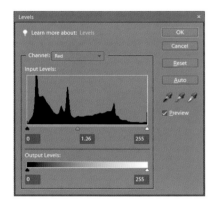

④ MAKE THE ADJUSTMENT

Click on the central gray arrow immediately below the histogram—the *Midtones* slider—and move it to the left. This will increase the amount of red in the picture. Getting the right amount of red might take a couple of tries, so just move the slider enough to give a subtle but obvious red cast.

The final image looks rich and appealing.

Creating a silhouette

Photography is about capturing the moment. But sometimes the moment isn't quite what you had hoped for.

Take this scene as an example. It was taken late in the afternoon on safari in Kenya's Masai Mara wildlife reserve. The photographer came across some elephants, but unfortunately, the lighting was poor. It was bright but cloudy, and there was no contrast.

The elephant pictures were taken anyway, with the idea of merging them against a sunset on the computer later. This shot was exposed for the sky, which underexposed the elephants—resulting in a great combination shot.

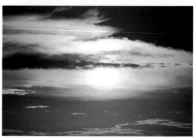

The two original images, taken at separate times.

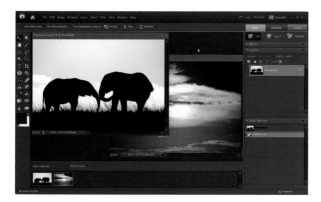

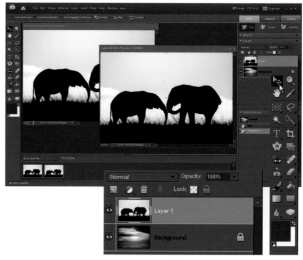

1 OPEN BOTH IMAGES
Start by opening the two images that you want to use. Do any adjusting or tidying up before going any further. Check that both images are the same dimensions and resolution by going to *Image>Resize>Image Size*, and resize if necessary.

2 BUILD A LAYER STACK
Move the silhouette image—in this case the elephants—onto the sunset by selecting the *Move* tool (shortcut key V), clicking on the image, and dragging it onto the sunset image. Holding down the Shift key at the same time ensures that the image is centered. This also creates a new layer so the two images are still separate.

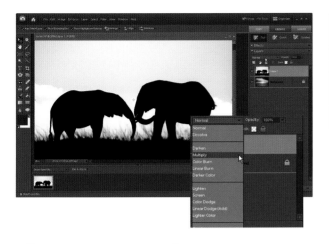

3 BLEND THE LAYERS

Close the elephant source image by clicking on the *Close* icon on the top right corner of the canvas or by using Ctrl+W.

Next, go to the *Layers* palette and click on the drop-down menu labeled *Normal* to reveal the *Layer Blend* modes available. Select *Multiply*.

4 FLATTEN LAYERS

Your sunset image is made up of two layers. You can leave it as it is—if you save it as a Photoshop file—so you can revisit the image at any time and alter it. However, you will save memory by going to *Layer>Flatten Image* so the image becomes a single layer.

Go to *File>Save As*, or use Shift+Ctrl+S, and give your final photo a new name. This will keep the original untouched; using *Save* will overwrite the original.

The *Multiply* blend mode reveals the sunset beneath the elephants, because the tone of the pixels in front and behind is multiplied and the darker color wins. The elephants are the darkest part of the image, but the light blue of the sky barely tints the strong, deeper sunset tones.

Coping with contrast

Strongly lit landscapes with dark foregrounds and bright skies can cause contrast problems. To cope with this situation, you need two images of different densities. You can obtain these by taking two exposures immediately after each other—ideally using a tripod to be sure they line up perfectly. Take one picture exposing for the shadows, so there is plenty of detail in the darker areas. Next, take one for the highlights. Neither picture will be perfect, but merging the two will result in a great photo.

Same photo taken at different exposures.

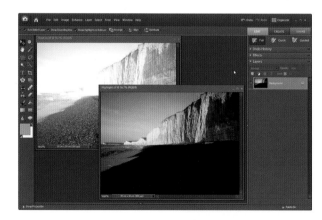

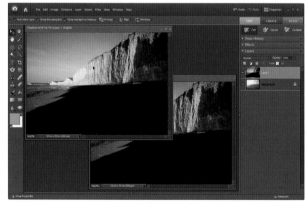

① START THE PROCESS

Open your two composite images. Be sure to name them Shadow and Highlight for clarity. With this technique making a copy of the *Background* layer is not essential, because work will not be done on the original at any time.

② MOVE THE PICTURE

Select the *Move* tool in the *Tools* palette. Click and hold the cursor on the Highlight image and drag it over to the Shadow image while holding down the Shift key. Release the mouse, and the Highlight image will be pasted into a new layer. It will be in perfect registration on top of the Shadow image. Close the Highlight image.

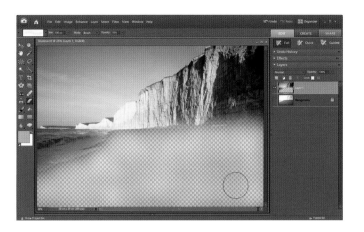

3 ZOOM IN

The new layer is active by default. You can check this in the *Layers* palette—the active layer is highlighted in gray. To see clearly, enlarge the image onscreen using the Ctrl+⊞ keys. Zoom out by using Ctrl+⊟ keys.

4 PREPARE THE BRUSH

Select the *Eraser* tool from the *Tools* palette. In the *Toolbox*, click on the arrow next to *Opacity* and adjust the slider to a lower setting, such as 10 percent, for greater control.

Right-clicking or clicking on the *Brush* tool icon brings up the *Brush Type* menu. You can pick a brush and make it bigger by using the square bracket (]) key.

5 ERASE AWAY

It is time to erase the top layer. It is best to erase a little at a time in many steps and make the brush smaller for more detailed areas. If you go wrong, use the *Undo History* menu, or press Ctrl+Z to go back one step.

Clicking on the *Eye* icon of the *Background* layer to switch it off reveals the quality of your erasing. It is important to take your time; switch the *Background* layer on and off to check your progress.

When you are finished, go to *Layer>Flatten Image* to make the image a single layer, then go to *File>Save As...* to leave the original image untouched.

Panoramic glory

A single photograph might not do justice for a stunning vista. So it may be worth taking a sequence of shots and stitching them together with special software to produce a panoramic image.

This panorama is comprised of eight individual images taken with a 50 mm lens. The camera was mounted on a standard tripod. A spirit level placed in the camera's hotshoe kept things level, but you can even merge handheld shots with modern software.

BUYER'S GUIDE

You can purchase panoramic tripod heads that are designed to give perfect joins between the images. However, you can also use a normal tripod, especially if you have an optional spirit level in the tripod or one that can be mounted in the camera's hotshoe—where flash units are normally placed.

1 PREPARE THE PICTURES

Elements has a *Photomerge* function with three options: *Photomerge Group Shot*, *Faces*, and *Panorama*. Opt for *File>New>Photomerge Panorama*.

2 CHOOSE THE PICTURES

In the *Photomerge* dialog box, leave the *Auto* option selected and click *Browse* to open a smaller window to choose the original images. This process works like opening any other file, but you can select more than one. Click *OK* and the software will do its work. This can take a while, depending on the size of your original files and the computer's processing speed.

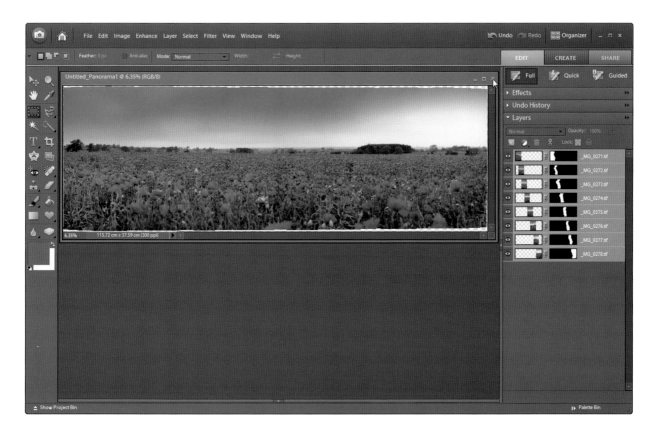

3 BE PATIENT

In this case, the software did a great job automatically. It helped that the sky was not very even, which could have shown the joins. Because the software puts each original image in its own layer, it is possible to make changes to each image.

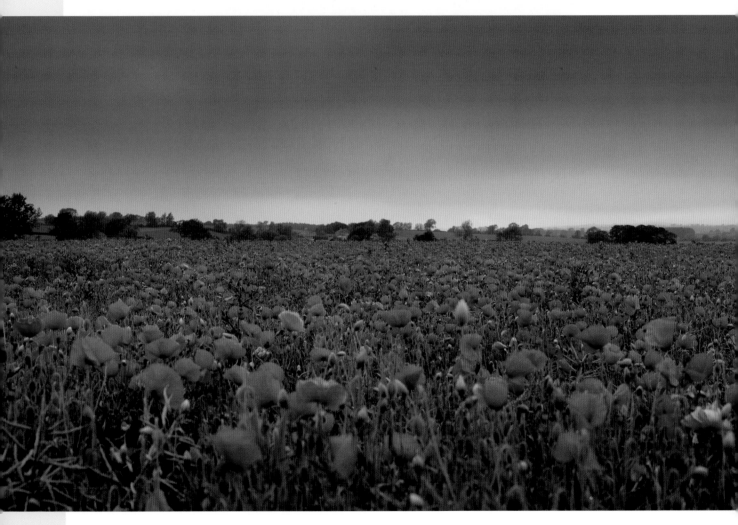

FINAL STEP
Once you have made any corrections, go to *Layer>Flatten Image*. This will also keep the file size down. Now select the *Crop* tool, crop the image, and save it.

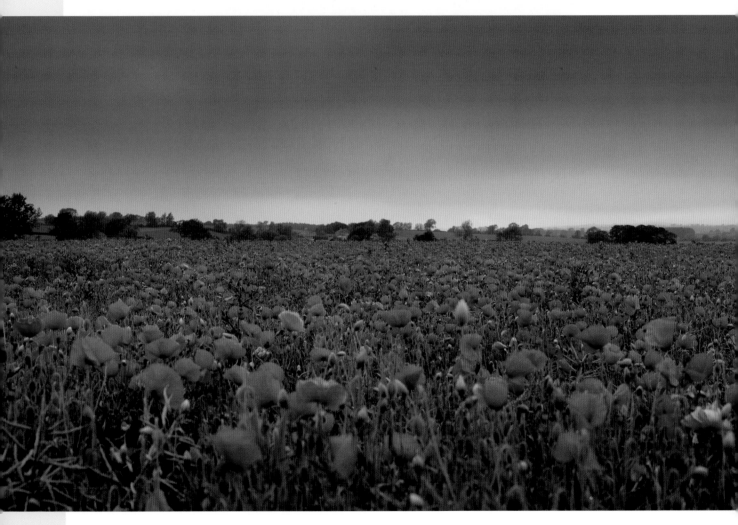

 HOW TO SHOOT A PANORAMA

Start by spending a few minutes setting up the camera. Switch it to manual metering mode and take a general reading of the scene. Also check the camera's white-balance mode. If it is in auto white-balance, change it to a preset that suits the lighting conditions.

Manual control will produce a set of pictures that is consistent in terms of exposure and white-balance, so when you are stitching, the joins between the images will not be noticeable. In auto mode the camera settings will probably change between frames.

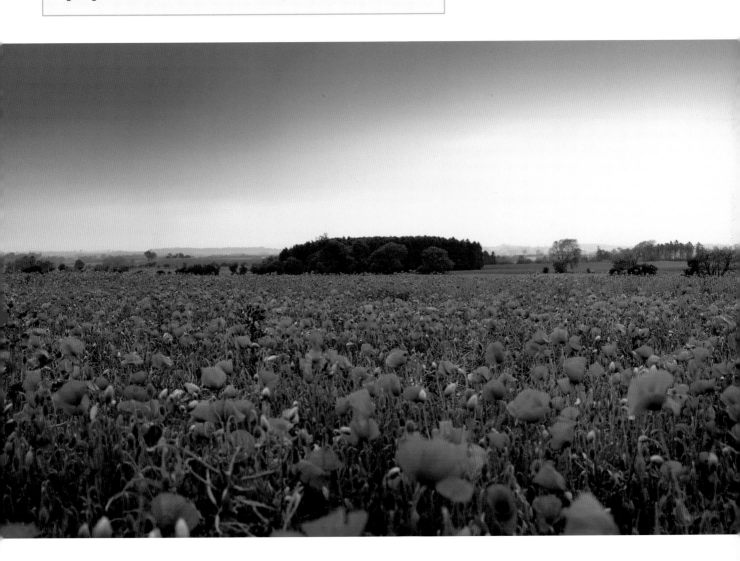

Life in black and white

Most people enjoy the natural appearance of a color photograph. However, there is something special about the abstract look of a well-produced black-and-white picture. With image-editing software, transforming a digital color picture to monochrome is straightforward and quick.

There are several methods to handling this conversion—some more effective and controllable than others.

Before

METHOD 1: **CONVERT TO GRAYSCALE**

You can convert an image to grayscale by going to *Image>Mode>Grayscale*. This method is the quickest, but it is also the least effective.

Contrast can go very flat; the blacks can lack depth, and the highlight regions can look gray rather than white.

METHOD 2: **REMOVE COLOR**

Color within an image can be removed by going to *Enhance>Adjust Color>Remove Color* (shortcut keys Shift+Ctrl+U). This process is more effective than converting to grayscale mode, and the images may have more sparkle. However, the depth of blacks and overall contrast can be less impressive than the following method.

The *Mono Conversion* method produces the best result because it is possible to emphasize the most important parts of the picture.

METHOD 3: MONO CONVERSION

In Elements there is the option to *Convert to Black and White*, which is also accessible using shortcut keys Alt+Ctrl+B. This brings up a dialog box that shows *Before* and *After* images so you can make a direct comparison. There are six presets for some popular subjects, including Portraits, Scenic Landscape, and Vivid Landscapes.

There are also four *Adjustment Intensity* sliders for controlling the color channels—red, green, and blue—and contrast. Any changes you make with these sliders are shown in the *After* window. For traditional film photographers, the effects are similar to using colored filters with black-and-white film.

Clicking *OK* in the top left of the window confirms the monochrome conversion. Then save as usual.

Digital toning

Adding color to black-and-white prints was once a popular darkroom technique; you are probably familiar with sepia-toned prints from years past.

Toning photographs digitally has several advantages over chemical processes. It is very easy, quick, repeatable, and there is no need for special equipment or materials. Furthermore, tones can be applied to any digital image. For example, you can shoot in full color and decide afterward that you want an image toned rather than lose the option to recover color information.

The original color image lacks special interest.

Four different color variations; the overwhelming favorite is the sepia image.

① START THE PROCESS

Copy the *Background* layer as usual. Next, go to *Enhance>Adjust Color>Adjust Hue/Saturation*. In the *Hue/ Saturation* dialog box, check the *Colorize* box and you will notice that the whole image will change color.

③ SATURATE OR NOT

Before closing the dialog box, it is worth trying different saturation levels. Click *OK* to confirm the effect.

② PICK ANY COLOR YOU WANT

Click and hold the *Hue* slider, move it left or right, and you will see the image color change. It is a simple matter of deciding which color you want.

④ CLEAN UP

The toned image is on a different layer, so you can still control the effect. Go to the *Layers* palette and click on the down arrow to the right of *Opacity*. Adjusting this from its default 100 percent setting will weaken the toning effect. Finish by going to *Layer>Flatten Image*.

Adding grain

It might seem odd to deliberately introduce digital noise, but it can be a very effective technique with the right type of picture.

The idea is to simulate the grain pattern that you would get from film. As a general rule, film with a higher ISO rating will result in a more obvious, coarse grain than lower ISO sensitivity films. This example uses a very pronounced effect to show what is possible. Many photographers add a subtle grain to their digital pictures simply to add a filmlike quality.

The beauty of this technique—adding grain to an extra layer by adjusting its opacity—is that it is very controllable.

The original color image has smooth tones.

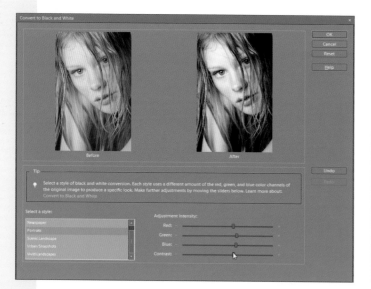

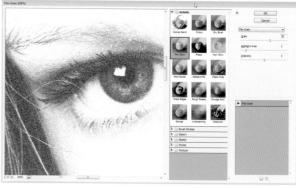

① START YOUR STYLE

Copy the *Background* layer and name it "Mono." Click *Enhance>Convert to Black and White* in the menu. It is worth trying different styles with this tool. In this example *Portraits* was selected; then the *Contrast* slider was moved a little to the right. Click *OK* to produce a monochrome image.

② PREPARE TO ADD GRAIN

Copy the *Mono* layer and name it Grain. With this layer active, go to *Filter>Artistic>Film Grain*. Set the image at 100 percent in the preview window. Experiment with different settings to produce an effect you like. Use the *Undo History* box to go back a step if you are not happy with the result. For an obvious effect set the *Grain* setting to 12 and *Intensity* to 5. Click *OK*.

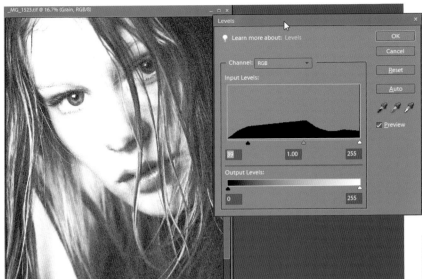

UP THE CONTRAST

Adding grain has reduced the contrast. This can be addressed by going to *Enhance>Adjust Lighting>Levels*. Move the black arrow to the right to make the image darker. Click *OK*.

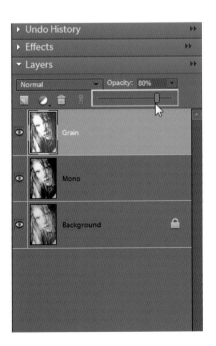

REFINE THE EFFECT

In the *Layers* palette, click on the down arrow to the right of *Opacity* to bring up the slider. Click and move this slider to the left to make the layer below show through. For this photo 80 percent was the right balance. When you are satisfied with the result, flatten and save as usual.

After black-and-white conversion and adding grain, the picture has a more artistic feel.

Showing and Sharing Your Prints

Creating artistic borders

An artistic print format can enhance the power of an already attractive shot. A professional-looking border will finish off a good photograph nicely or make the most of a less impressive picture.

Software such as Elements provides many options to try, which allow you to express your creative side.

Before

KEYLINE BORDERS

Adding a thin keyline border to a print can add definition, especially if you are printing a photo with a large white margin around it.

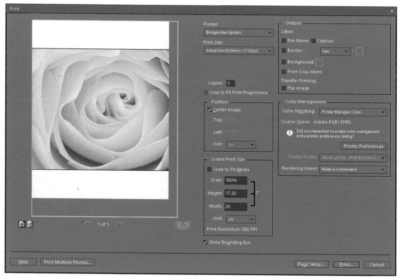

1 PRINT MENU
Adding a keyline when you print does not change your image file, so open your image and make your enhancements. Next click *File>Print* in the menu.

2 ROTATE
To the left of the dialog box is a print preview of the image, and to the right is a series of options. If your picture is landscape and the page is set up in portrait mode, click on the *Landscape* button at the bottom-left of the preview area.

After

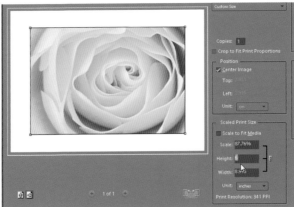

SET THE MARGIN

4 You do not have to accept the default image size. The computer will automatically scale the image to any size you choose, interpolating where it is necessary. How to sidestep the need to resize the image with the *Image Resize* tool is discussed on page 126. Type a new value into the *Scale*, *Height*, or *Width* box and the other two will be proportionally scaled to fit. The result will be reflected in the preview.

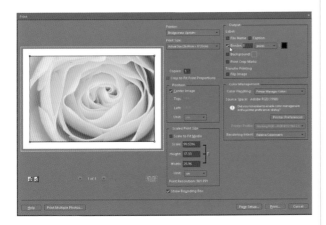

SET THE BORDER

3 In the *Output* panel at the top right of the *Print* dialog box you will find a *Border* option. Check the box, and choose *Points* from the drop-down menu. One or two points is usually sufficient for prints up to Letter (A4) size, so type 1 or 2 into the box. You can also change the color of the border, but black works well.

PRINTING YOUR PHOTO

5 Be sure to have the right paper in your printer and that it is switched on and ready. Click *Print* to send the instructions to your printer. There is more information on this process on pages 158 to 161.

RAGGED BORDER

You can add interest to your prints with an uneven border.

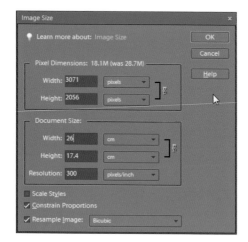

Before

CHECK THE IMAGE SIZE

Open the image and check its size by going to *Image>Resize>Image Size*. The image needs to be smaller than the paper size you will use to print. Make a mental note of the resolution figure.

After

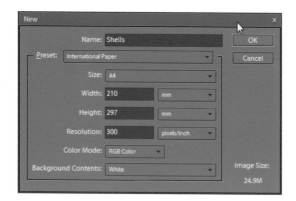

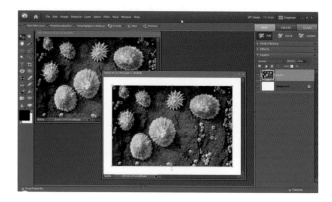

CHOOSE PAPER SIZE

Next go to *New>Blank File* and choose the appropriate paper size. Set a figure to match your image in the *Resolution* box. A different resolution will change the image size.

IMPORT THE IMAGE

Go back to the image. Click and hold the mouse, and drag the image to your new blank document. Holding the Shift key down will keep the image central. If you want to adjust it, use the arrow keys to nudge the image until you are happy with its position.

SAVE FOR NOW

4 Close the original source image without saving. Next save the new document, so if you make a mistake you can use *Undo History* to go back to this point. Select the *Erase* tool from the *Tool* palette.

ERASE AWAY

6 Next you will create a ragged border by erasing the edges of the image with your brush. Brush size can be quickly changed using the square bracket [] keys or the *Size* slider in the *Toolbar*. Magnifying the image on-screen using the Ctrl+ ⊕ keys will help you see your work. Take your time and erase a little at a time, so if you need the *Undo History*, you only go back a few stops.

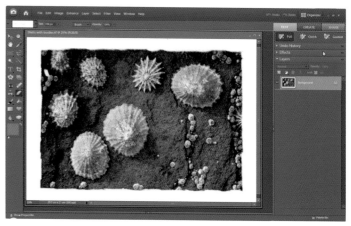

BRUSH SELECTION

5 Clicking on the *Brush* window in the *Tool Options* bar or right clicking the mouse will bring up brush options. For the ragged brush effect, the *Pastel on Charcoal Paper* option in the *Dry Media Brushes* menu was selected. You will find many options to explore.

FINAL STEP

7 Once you are happy with the border go to *Layer>Flatten Image* and save.

Printing at home

One of the many joys of digital photography is the ability to print at home. You can have a professional-quality print in your hands literally minutes after taking the photograph. And with some models you can skip the computer and print directly from a storage card.

Printers come with a variety of software—some contain special effects but the key element is the driver. This tells your computer how to send instructions to the printer. Be sure to follow the instructions to install the software and set up the ink cartridges.

Color management

Using the same color space throughout your image processing chain will help guarantee the best possible results. DSLRs offer two color space options: sRGB and Adobe RGB. Broadly speaking, the sRGB color space has a narrow range of colors called gamut, and it is designed for pictures that are going on the Internet.

The recommended color space for optimal print output is Adobe RGB, and it has a wide color range. However, most people—even experts—will have a hard job seeing any difference between the two color spaces on the final print. The most important step is to have the color settings in your camera and your imaging software set up for the same type of color space.

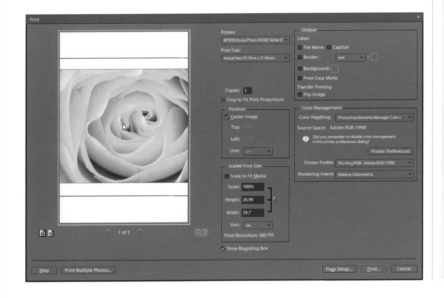

① PREPARE TO PRINT

Start by preparing your image in Elements; make it the right size and add a border. Next go to *File>Print*. In this example the alignment is incorrect, so enter *Page Setup* and be sure to choose the correct paper size and orientation.

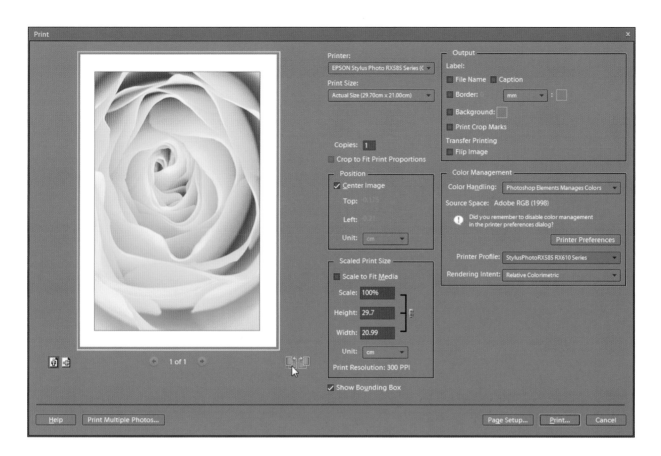

2 CHOOSE A FEW SETTINGS

Return to the printer window—the orientation is now correct. However, make sure the number of copies is correct and the image is centered. Under *Color Handling*, choose *Photoshop Elements Manages Colors*. Next under *Printer Profile* choose the setting to match your printer model. And for *Rendering Intent*, choose *Relative Colormetric*.

3 FINE-TUNING

Now click on *Printer Preferences* and in the *Main* window, choose the right paper finish, size, and print quality. There are also some options specific to your printer; this Epson model lets you know how much ink still remains.

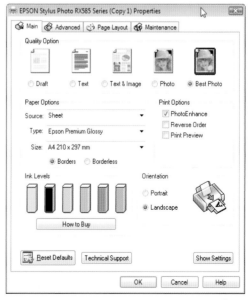

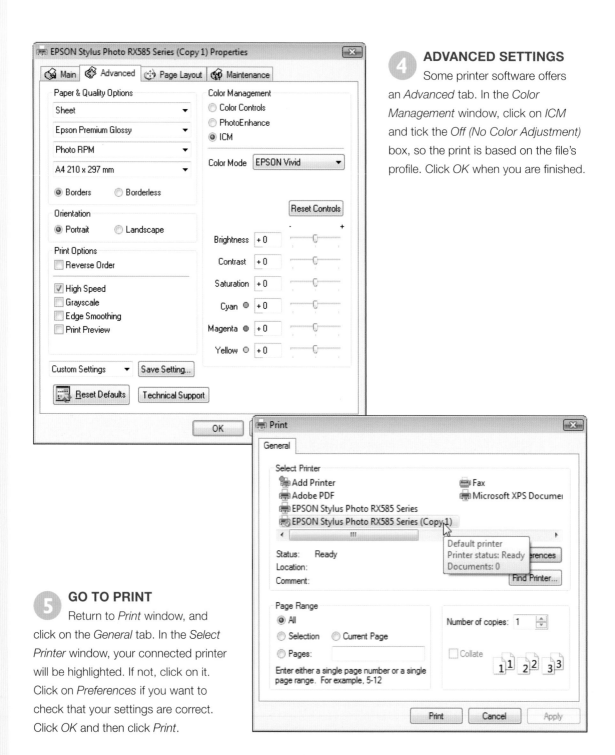

ADVANCED SETTINGS

4 Some printer software offers an *Advanced* tab. In the *Color Management* window, click on *ICM* and tick the *Off (No Color Adjustment)* box, so the print is based on the file's profile. Click *OK* when you are finished.

GO TO PRINT

5 Return to *Print* window, and click on the *General* tab. In the *Select Printer* window, your connected printer will be highlighted. If not, click on it. Click on *Preferences* if you want to check that your settings are correct. Click *OK* and then click *Print*.

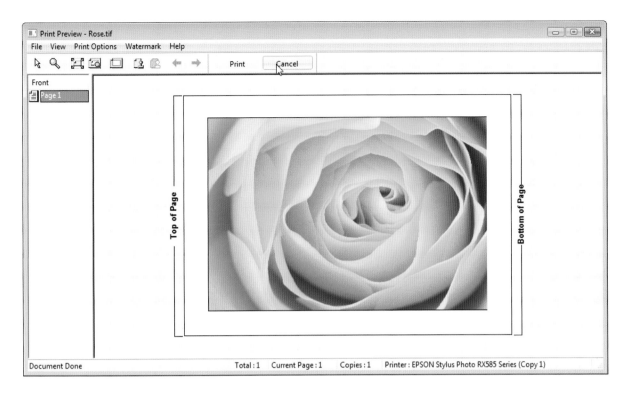

FINAL STEP

6 Your printer software may offer a *Print Preview* option. Choosing it shows you how the final print will come out; a useful final review that prevents wasting paper. If you are happy with the *Print Preview*, click *Print*. A short while later, the print progress monitor will appear. In a few minutes you will have a finished print in your hands.

Printing kiosks

Many people are accustomed to sending film to a processor for finished prints. However, it is also possible to visit a photo store and get prints over the counter from a storage card, flash drive, or a CD/DVD produced on your computer.

Photo kiosks are now becoming popular fixtures in local stores. With touchscreens and easy-to-follow instructions, getting prints from a photo kiosk is straightforward and the quality is very high. You will also find functions for basic image corrections, such as removing red-eye and cropping—which is essential to fit the provided paper sizes.

Ordering prints online

The Internet offers plenty of opportunities to share and enjoy your photography. You can post pictures on social networking, portfolio, and amateur photography sites. Plus you can get feedback about your pictures from fellow photographers and use it to improve the quality of your work.

The Internet also enables you to get high-quality prints without leaving the comfort of your home. There are many online processing laboratories that will send a wide variety of prints to you.

ONLINE PRINTING SERVICES

Before you can order prints, design photo books, or order gifts featuring your pictures, you have to set up an account with an online printing service. This is free and easy; all you usually need is an e-mail address and a password.

While it is a simple procedure to upload pictures, it is important to follow the instructions, particularly regarding file size. Be sure to only send JPEGs, which are smaller and quicker to upload. You may need to reduce their size, too, but keep copies of the full-resolution originals.

Once your pictures are uploaded, you have the freedom to do what you want with them—whether you want to make a photo album, put a picture on a mug, or just order a few enlargements. If you place an online order, it will arrive in the mail. Some sites also offer the possibility to invite family and friends to view your photos and order prints, too.

HOW TO CREATE YOUR OWN PHOTO BOOK

Making prints and sticking them in a traditional photo album is fulfilling, fun, and easy. Making a custom photo album on-screen rates just as high, but it is even more versatile because you can add captions and vary the layout to your heart's content. And the finished result will look very professional.

① SIGN IN
Log on to your processing service and select the photo book function.

② PICK A COVER
You can choose your cover design, album size, number of pages, and theme by clicking on preview icons.

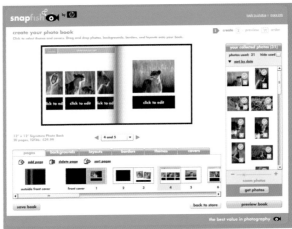

FILL THE ALBUM

Explore the design options. You may be able to let the service design your album, or you might prefer to design your own layout.

CREATE YOUR ALBUM

This is the important stage, so take your time to try different layouts and make sure that the pictures work together. This is when you can add captions.

CHOOSE YOUR PHOTOS

Upload your pictures to create an album. Over a period of time you may have several albums, so select the one you want to turn into an album.

FINAL STEP

When you have previewed the album and you are happy with the results, proceed to the ordering and payment stages. Then sit back and wait for your own professional-quality photo book to arrive in the mail.

Making a slideshow

It is satisfying and fun to share your photographs in a slideshow that you can view on a computer, television, or website. There are many slideshow programs available; for this tutorial we used Photodex ProShow Gold.

 The key to a successful slideshow is to begin with tight editing. You do not want your viewers to sit through hours of dull pictures. Go through your pictures carefully and pick out only those that really shine.

SORT OUT YOUR PICTURES
Put your prospective slideshow shots in a folder. Open ProShow Gold and locate the folder that contains these images.

2 OPEN THE SOFTWARE
Click and drag your images into the timeline window. The order in which images are shown is easily altered, so you can rearrange them.

3 EDIT THE IMAGES
Characteristics, such as brightness, hue, and contrast, can be fine-tuned. It is also possible to vary the crop of each image.

VARY THE TRANSITIONS

4 Fine-tune your show by choosing the style of the transitions between slides.

ADD SOUND

6 A soundtrack can be added from a music CD. This can be tailored to suit the needs or mood of the presentation.

ADD THE WORDS

5 Add a title for your presentation and any other captions you want to include.

FINALIZE THE SHOW

7 Finally, decide on your slideshow format. ProShow Gold provides plenty of options.

Caring for your images

After all of the time, effort, and money it takes to create pictures that make you proud, it would be tragic if they were lost forever in the depths of your computer's hard drive.

One of the biggest joys of photography is being able to look at your pictures at any time. Be sure to back up your files to minimize the risk of losing any pictures due to technical or man-made error.

In some ways prints are less important than digital files because as long as you have the digital file, you can produce a print. Nevertheless, it pays to look after your prints, too.

Catalog your pictures

The *Organize* function of Elements will let you catalog and keyword, or tag, your digital files, which makes locating pictures easy. Thumbnails of your pictures are shown in a photo browser and there is the option of *Date View* where you can see images laid out in a calendar format.

BACKUP DRIVES

Regardless of your computer hard drive's capacity, an external hard drive is an important investment. Storage space is getting cheaper all of the time; drives with a capacity of 500 GB or more are now very affordable.

Moving your photo files off of the computer's hard drive has two benefits: if you have less information stored on the computer, it maintains a fast operating speed. And a computer hard drive can crash at any time, so having copies of your pictures is a valuable safety net. Of course, the external hard drive can also crash. Therefore, you need to back up to a DVD, too.

It takes discipline and a little effort to regularly backup your files, but the effort is worth it. If you have lost pictures through mechanical failure in the past, you will appreciate these important steps.

LOOK AFTER PRINTS

As soon as they are printed, photos start to deteriorate due to light, moisture, or airborne fumes. However, with modern materials this rate of deterioration is imperceptible. It can take many years, depending on the materials used to produce the print as well as storage or display conditions.

The photographic papers used by processing laboratories, such as Kodak Supra Endura and Fuji Crystal Archive have very good storage characteristics, and they will last a lifetime with careful storage.

On the home-printing front, in the early days inks were not very lightfast, and prints could fade within months—especially if displayed in daylight. The good news is that the printer, ink, and paper manufacturers have worked hard to improve this situation. The latest ink-jet printing materials are excellent in terms of stability.

Archival print storage is a complex topic with many imponderables. Unless you are selling your prints, it is not usually worth the worry.

Generally, bear in mind that prints, even behind glass, will gradually fade. However, pictures in a good-quality photo album will outlast you.

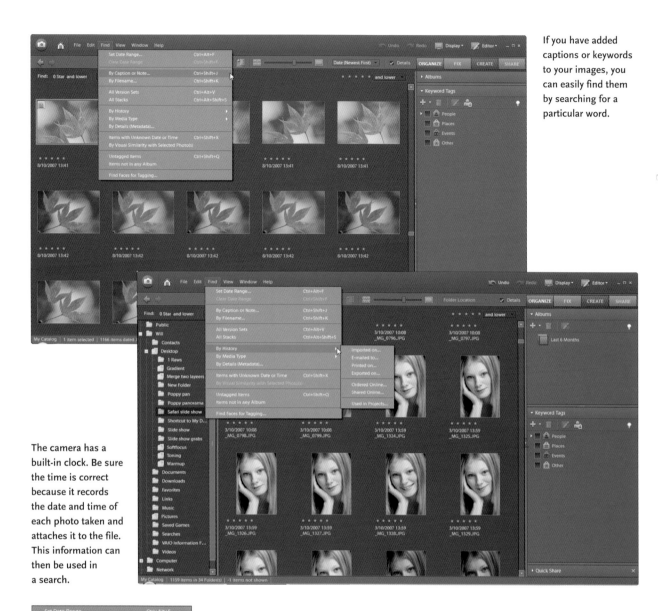

If you have added captions or keywords to your images, you can easily find them by searching for a particular word.

The camera has a built-in clock. Be sure the time is correct because it records the date and time of each photo taken and attaches it to the file. This information can then be used in a search.

The full list of search options under the Organize function's Find menu.

Glossary

accessory shoe Mount to accommodate add-ons, such as a separate flash.

alpha channel While each color channel defines the level of a certain color for each pixel, this channel defines the level of transparency for each pixel, allowing you to create images with objects of varying levels of transparency.

anti-aliasing The smoothing of jagged edges on diagonal lines created in an imaging program by giving intermediate values to pixels between the steps. This is especially common around text.

aperture priority A camera mode in which you set a target aperture and the camera will use its light readings and automatically adjust the shutter speed to correctly expose the picture.

application Software designed to make the computer perform a specific task. For example, Photoshop is an image-editing application, whereas Windows is an operating system.

artifact Any flaw in a digital image, such as "noise." Most artifacts are undesirable, although adding noise can create a desirable grainy texture.

autofocus (af) A mechanism that automatically adjusts the camera's focus to bring the selected zone of the picture into sharp focus. Autofocus can usually be switched from servo mode, which tracks moving objects, to fixed mode. It can also be switched off altogether, usually using a separate switch.

backup A copy of either a file or a program created in case the original file becomes damaged (corrupt) or lost.

bit depth The number of bits per pixel (usually per channel, sometimes for all the channels combined), which determines the number of colors that pixel can display. Eight bits-per-channel are needed for photographic-quality imaging.

Blu-Ray disk A newer digital media format which, while the same physical size as a CD or DVD, can store much more data. It is commonly used as a high-definition home entertainment format, and can store 25 GB or 50 GB of data.

body The camera body is the main camera housing, which includes the shutter mechanism, image sensor, viewfinder, and LCD display. Different lenses can be attached to the body via the lens mount, and other accessories via the accessory shoe.

browser Program that enables the viewing or browsing of files. You might have one browser to look through image files and another to browse the Internet.

burning The act of recording data onto a CD, DVD, or Blu-Ray disk using a suitable burner (a recordable disk drive).

byte Eight bits. The basic data unit of desktop computing. Eight binary bits can hold up to 256 possible values.

CCD (Charged Coupled Device) One of two common varieties of image sensor components in digital cameras. The other is CMOS. This part "sees" and records the images, like film does in a traditional camera. The CCD is made up of a grid of tiny light sensors, one for each pixel. The number of sensors, and the size of image output by the CCD, is measured in megapixels.

CD-ROM CD (Compact Disk) Read-Only Memory. An evolution of the CD that allows the storage of up to 700 megabytes of data, such as images, video clips,

text, and other digital files. A CD-R can be written onto once. A CD-RW can be erased and reused any number of times.

channel Images are commonly described in terms of channels, which can be viewed as a sheet of color similar to a layer. Usually, a color image will have a channel allocated to each primary color (red, green and blue in a standard RGB image) and sometimes an alpha channel for transparency, or even an additional channel for professional printing with special inks.

clone/cloning In most image-editing packages, clone tools allow the user to sample pixels (picture elements) from one part of an image, such as a digital photograph, and use them to "paint" over another area of the image. This process is often used for the removal of unwanted parts of an image or correcting problems, such as facial blemishes. In Photoshop the tool is called the *Clone Stamp* tool.

CMYK The standard primary colors used by professional, or "process," printing: cyan, magenta, yellow and key (black). These colors are mixed according to "subtractive color," meaning that white appears where no color value is applied.

color depth See bit depth.

color gamut The range of color that can be produced by an output device, such as a printer, a monitor, or a film recorder.

compression The technique of rearranging digital data so that it either occupies less space on a disk or transfers faster between devices or over communication lines.

continuous-tone image An image, such as a photograph, in which there is a

smooth progression of tones from black to white.

contrast The degree of difference between adjacent tones in an image from the lightest to the darkest. "High contrast" describes an image with light highlights and dark shadows, but few shades in between, while a "low contrast" image is one with even tones and few dark areas or highlights.

copyright The right of a person who creates an original work—including taking a photograph, for example—to protect that work by controlling how and where it may be reproduced.

digitize To convert anything—text, images, or sound—into binary form so it can be digitally processed. In other words, transforming analog data (a traditional photograph or an audio tape, for example) into digital data.

dithering A technique by which a large range of colors can be simulated by mingling pixels. A complex pattern of intermingling adjacent pixels of two colors gives the illusion of a third color, although this makes the image appear grainy.

dots per inch (dpi) A unit of measurement used to represent the resolution of output devices, such as printers and also, erroneously, monitors and images, whose resolution are expressed in pixels per inch (ppi). The closer the dots or pixels (the more there are to each inch), the better the quality. Typical resolutions are 72 ppi for a monitor, 600 dpi for a laser printer, and 1,440 dpi for an ink-jet printer.

download To transfer data from a remote computer, such as an Internet server, to your own. The opposite of upload.

DVD (Digital Versatile Disk) Similar in appearance to CDs and CD-ROMs, but with a much larger storage capacity.

Although store-bought movie DVDs hold up to 9 GB per side the most common DVD±R and DVD±RW formats hold 4.4 GB. The larger capacity DVD+R DL (dual layer) format is increasingly common, but the media are usually more expensive.

EPS (Encapsulated PostScript) An image file format for object-oriented graphics, such as drawing programs and page-layout programs.

extract A process in many image-editing applications where a selected part of an image is removed from areas around it. Typically, a subject is "extracted" from the background.

eyedropper A tool in some applications for gauging the color of adjacent pixels.

ƒ-stop Measurement of the diameter of the camera's aperture. The lower the number, the wider the aperture, and the more light reaches the sensor; ƒ1.4 is a wide aperture, ƒ22 is a narrow aperture. Photographer's use the word stops because traditional lenses would click into place at certain predefined points, which made it easier to anticipate how much light would pass through the aperture.

file extension The term for the abbreviated suffix at the end of a file name that describes either its type (such as .eps or .jpg) or origin. Extensions are compulsory and essentially automatic in Windows, but not in Apple computers. Mac users need to add them if they want their files to work on Windows computers.

file format The way a program arranges data so that it can be stored or displayed on a computer. Common file formats include TIFF (.tif) and JPEG (.jpg) for bitmapped image files, EPS (.eps) for object-oriented image files, and ASCII (.txt) for text files.

FireWire A type of port connection that

allows for high-speed transfer of data between a computer and peripheral devices. Also known as IEEE-1394 or iLink, this method of transfer—quick enough for digital video—is employed by some high-resolution cameras to move data faster than USB.

GB (GigaByte) Approximately one billion bytes (actually 1,073,741,824), or 1024 megabytes. 1,024 is preferred to 1,000 because it is 128×8, numbers which make life easier for computers.

GIF (Graphics Interchange Format) One of the main bitmapped image formats used on the Internet. The GIF format uses a "lossless" compression technique, which handles areas of similar color well, and allows animation. It is therefore the most common format for graphics and logos on the Internet, but JPEG is usually preferred for photographs.

gradation/gradient The smooth transition from one color or tone to another. Photoshop and other programs include a *Gradient* tool to create these transitions automatically. This is useful if you want to recreate the effect or an artificial gradient filter to give your picture a striking sky.

histogram A map of the distribution of tones in an image, arranged as a graph. The horizontal axis is in 256 steps from black to white (or dark to light), and the vertical axis is the number of pixels. In a dark image you'll find taller bars in the darker shades.

HSL (Hue, Saturation, Lightness) A representation of colors based on the way that colors are transmitted from a TV screen or monitor. The hue is the pure color from the spectrum, the saturation is the intensity of the color pigment (without black or white added), and brightness represents the strength of luminance from light to dark (the amount of black or

white present). It is also sometimes called HLS (hue, lightness, saturation), HSV (hue, saturation, value) and HSB (hue, saturation, brightness) in different software.

hue A color found in its pure state in the spectrum.

interface A term used to describe the screen design that links the user with the computer program or website. The quality of the user interface often determines how well users will be able to navigate their way around the pages within the site.

interpolation Bitmapping procedure used in resizing an image to maintain resolution. When the number of pixels is increased, interpolation fills in the gaps by comparing the values of adjacent pixels.

ISO rating The standard measurement of light sensitivity. A lower ISO number, like 100, means the sensor is less responsive to light, so the shutter needs to be open for longer or the aperture wider for the same result. Higher ISO numbers, like 1600, are prone to digital noise—a fine textured pattern usually considered ugly.

JPEG, JPG The Joint Photographic Experts Group. An ISO (International Standards Organization) group that defines compression standards for bitmapped color images. The abbreviated form gives its name to a "lossy" (meaning some data may be lost) compressed file format in which the degree of compression, ranging from high compression and low quality to low compression and high quality, can be defined by the user.

KB (kilobyte) 1,024 bytes.

lasso A selection tool used to draw an outline around an area.

layer One level of an image file, separate from the rest, allowing different elements to be moved and edited in much the same way as animators draw onto sheets of transparent acetate.

lens Strictly speaking, the word refers to a single piece of glass or other material that light passes through. But Digital SLR users always use it to refer to the detachable barrels, which may be made up of several physical lenses and include a zoom mechanism, focusing mechanism, and even stabilization technology.

lens mount The part of the camera body to which a lens can be fitted. Camera manufacturers only have a limited number of different lens mounts, so lenses can be compatible with as many camera models of camera as possible. The mount also allows for the electronic transfer of information and power for the autofocus and metadata systems.

lens release The button which is held to allow the lens to be detached from the camera body.

lossless/lossy Refers to the data-losing qualities of different compression methods. "Lossless" means that no image information is lost; "lossy" means that some (or much) of the image data is lost in the compression process (but the data will download quicker).

luminosity Brightness of color. This does not affect the hue or color saturation.

mask A grayscale template that hides part of an image. One of the most important tools in editing an image, it is used to make changes to a limited area. In Photoshop Elements a mask can only be applied to an adjustment layer, but in Photoshop masks can be applied to all layers.

MB (megabyte) Approximately one million bytes (actually 1,048,576).

megapixel This has become the typical measure of the resolution of a digital camera's image sensor. It is simply the number of pixels on the image sensor, so a size of 1280 x 960 pixels is equal to 1228800 pixels, or 1.2 megapixels.

memory card The media used by a digital camera to save photos. This can be Compact Flash, Memory Stick, SD Cards or Smart Media. These all store images that can be transferred to the computer.

menu An on-screen list of choices available to the user.

metadata Digital information about an image (or other) file that is attached to the file. Typically this means a picture file that includes information about the settings used when the image was shot, or even the names of the subjects and the location.

midtones/middletones The range of tonal values in an image anywhere between the darkest and lightest, usually referring to those approximately halfway.

noise Random pattern of small spots on a digital image that are generally unwanted, caused by non-image-forming electrical signals. Noise is a type of artifact.

pixel (picture element) The smallest component of any digital image. In its simplest form, one pixel corresponds to a single bit: 0 = off or white, and 1 = on or black. In color or grayscale images or monitors, one pixel may correspond to several bits. An 8-bit pixel, for example, can be displayed in any of 256 colors, a 24-bit pixel (8 bits per channel) can display any one of 16.8 million colors.

pixels per inch (ppi) A measure of resolution for a bitmapped image.

plug-in Subsidiary software for a browser or another package that enables it to perform additional functions, such as play sound, movies, or video.

RAM (Random Access Memory) The working memory of a computer to which the central processing unit (CPU) has direct, immediate access. The data is only stored while the computer is switched on. More RAM can dramatically improve a computer's performance.

resampling Changing the resolution of an image either by removing pixels (lowering the resolution) or adding them by interpolation (increasing the resolution).

resolution (1) The degree of quality, definition, or clarity with which an image is reproduced or displayed, for example in a photograph, or via a scanner, monitor screen, printer, or other output device.

resolution (2) The monitor or screen resolution. The number of pixels across by pixels down. Common resolutions are 1024 × 768 or 1680 × 1050.

RGB (Red, Green, Blue) The primary colors of the "additive" color model, used in video technology, computer monitors, and for the Web.

ROM (Read-Only Memory) Memory, such as on a CD-ROM, which can only be read. It retains its contents without power, unlike RAM.

shutter The mechanism that exposes the image sensor chip to light for a brief period, usually no more than a fraction of a second. The shutter can be operated using the shutter release button or using a remote—cable or infrared—release.

shutter priority (S/Tv) A camera mode in which you select the shutter speed and the camera automatically adjusts the aperture based on its light measurements, so the picture is correctly exposed.

shutter speed A measurement of how long the shutter is open when taking a photograph. In the case of action photography, a very fast speed, like 1/2000 sec, might be used. However, in the evening you may want the shutter to be open for several seconds.

SLR (single lens reflex) This acronym is used to describe all cameras that employ an SLR mechanism. But strictly speaking it refers to the moving mirror mechanism that allows you to compose your photograph through the same lens will subsequently expose the sensor.

software Programs that enable a computer to perform tasks, from its operating system to job-specific applications such as image-editing programs and third-party filters.

thumbnail A small representation of an image used mainly for identification purposes in a file browser or, within Photoshop, to illustrate the current status of layers and channels.

TIFF (Tagged Image File Format) A standard and popular graphics file format used for scanned, high-resolution, bitmapped images and for color separations. The TIFF format stores each pixel's color individually, with no compression, at whatever bit depth you choose. That means pixels can be black and white, grayscale, RGB color, or CMYK color, and can be read by different computer platforms, but are very large files. For example, an image of 640 × 480 pixels (just 0.3 megapixels) at 8 bits per channel CMYK (32 bits per pixel) is 1.2 MB.

toolbox In an application, an area of the interface that enables instant access to the most commonly used features.

transparency A degree of transparency applied to a pixel so, when the image or layer is used in conjunction with others, it can be seen through. Only some file formats allow for transparency, including TIFFs, which define transparency as an alpha channel, or GIFs. These only allow only absolute transparency—a pixel is either colored or transparent.

USB (Universal Serial Bus) An interface standard developed to replace the slow, unreliable serial and parallel ports on computers. USB allows devices to be plugged and unplugged while the computer is switched on. It is now the standard means for connecting printers, scanners, and digital cameras.

X-sync speed The fastest speed you can use the shutter with the flash. Because the shutter operates using two moving curtains—one opening and the other closing—not all of the sensor needs to be exposed to the light at any one moment. The flash is very quick, and if the flash fires while the sensor is partially exposed, then that area will be the only part of the picture that appears flashlit.

Index

Acknowledgments

A great many people helped and supported me in the production of this book, and this is my opportunity to say a massive "thank you" to everyone involved.

There are a few people that deserve special recognition starting with Chris Gatcum and Adam Juniper of Ilex Press. It was Chris who first suggested me as this book's author, while Adam has shown enormous patience as my senior editor working on this project.

Next I want to thank my partner Jo who did all of the cooking and kept me supplied with tea and red wine during those long winter nights in front of the computer.

Lastly, I want thank you for picking up this book, and may I wish you huge enjoyment with your digital SLR camera. Photography is the ultimate medium for recording life's golden memories as well as expressing yourself creatively. And it is great fun, so welcome aboard!

William Cheung FRPS